The Jeweler's Art

A MULTIMEDIA APPROACH

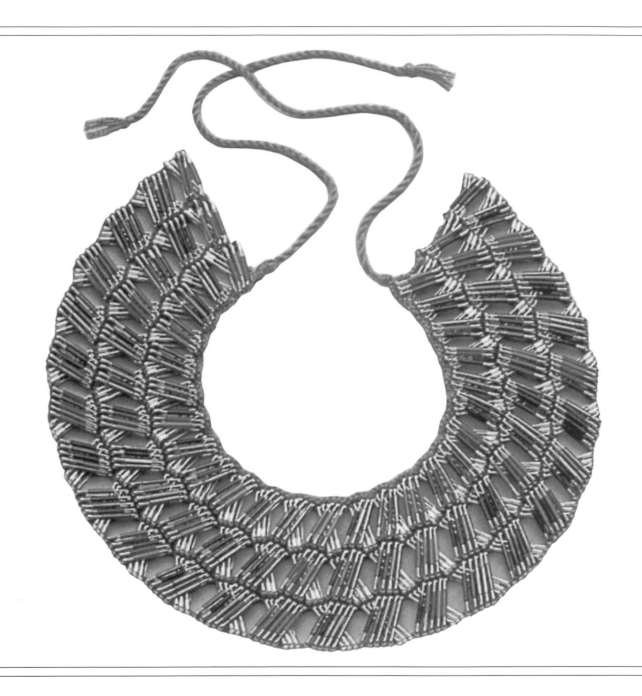

The Jeweler's Art

A MULTIMEDIA APPROACH

Alice Sprintzen

Davis Publications, Inc. Worcester, Massachusetts

To the many students and educators of crafts
whose work makes this world a more beautiful and
meaningful place.

Copyright © 1995
Davis Publications, Inc.
Worcester, Massachusetts U.S.A.

Cover: Kiff Slemmons, *Measure Up: To School*, 1991. Silver,
brass and pencils.
Design: Janis Owens

Printed in the United States of America

Library of Congress Catalog Card Number: 93-74647

ISBN: 87192-279-7

10 9 8 7 6 5 4 3 2

Contents

1 Metal

2 *Clay*

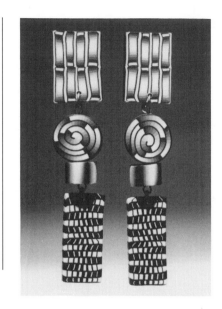

3 *Paper*

4 Leather

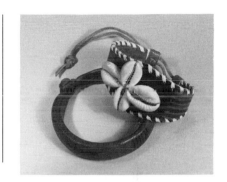

5 Fiber

6 Glass

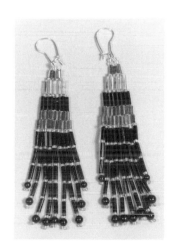

7 *Alternative and Mixed Media*

Acknowledgments

I wish to express my gratitude to the many artists who generously contributed photographs of their jewelry to this book. Their work has been an inspiration to me and I am delighted to be able to share it with my readers.

Special thanks are in order to Emelyn Garofolo, Larissa Rosenstock and Burt Spiegel for allowing me to photograph them in action and to David Luck, who took his own process photographs on hammer-forming.

I am indebted to the American Craft Council Library, the Brookfield Crafts Center (in particular, Dee Wagner) and the Center for Safety in the Arts for their resources and assistance. Michael McCann deserves special praise for his work in health and safety in the arts. I am in awe of his ability to accomplish so much and still manage to find the time to assist callers like myself.

Doug Smith and Mary Grace Dougherty of Space Lab did an excellent job of processing the photographs. Mary's mini-gallery made each trip to her lab an aesthetic experience. Diane Nelson of the Ferrin Gallery in Northampton, Massachusetts, Jerry Fotinatos of the Stained Glass Workshop in Syosset, New York and Edward Lowe of Wasser Glass went out of their way to help track down jewelers and gather technical information.

The members of the Long Island Craft Guild were supportive and helpful throughout. With them, networking is more than just a word. It is an expression of shared concern and encouragement.

I would also like to thank my colleagues and students at Oyster Bay High School, who have provided me with inspiration and a sustaining community for many years.

Shirley Hochman deserves a special expression of appreciation for her willingness to assist in editing my manuscript whenever she was called upon to do so.

I am ever grateful to my friends and family, especially my husband, David, who has been a constant source of support and encouragement. He helped me to put things in perspective and pace myself. Likewise, to my son, Daniel, whose presence and character remain a constant source of joy.

Introduction

With a striking arrangement of colors and textures, a unique interpretation and an unexpected combination of materials, you may create a piece of jewelry that is a miniature work of art. Jewelry can be fashioned from virtually any material and with practically any technique. Wearability is the only constraint.

Even if you are not an artist and have never considered making jewelry, you may find inspiration in the pages that follow. In the broad range of approaches presented, one process may spark a beginning. Remember—there is no unique way to design jewelry. In the development of your work, the piece you reject may be as important as the piece you accept. Technical skill is acquired naturally, with practice. The learning process is one that is both engaging and fulfilling.

Process photographs suggest learning paths that may assist beginners in the development of skills and a sense of the importance of good craftsmanship and safety. Seasoned jewelers will find ideas and techniques that offer a fresh approach, enabling them to take their work a step beyond.

From the claw necklace of the cave dweller to the dramatic aesthetic statements of contemporary jewelers, centuries of redefinition have marked the process of creation. Over time, new techniques and materials have been introduced. What has emerged is a field booming with innovation and creativity. The line between fine art and craft has become blurred.

Many artists with backgrounds in different media design jewelry that combines their past training and experience with newly acquired techniques. This merging of diverse aspects of the world of art has spawned an exciting array of new jewelry that challenges many old concepts.

Traditionally jewelry has been worn as a symbol of power, status, wealth, group, clan or religious affiliation, marital status or personal adornment. Today, however, jewelry is often used as a means for the expression of personal uniqueness. With global forms of communication, inspiration pours forth from all corners of the world. Jewelers have found an ever-widening audience, educated by the growing number of sophisticated crafts galleries and museum exhibitions.

Social values are also reflected in the art of any period, and ours is no exception. Although precious materials and technical ability will always be something to admire, novelty is especially valued today. Collectors purchase jewelry made from materials as diverse as paper, clay, feathers—even zippers and safety pins. The nonconventional has become the rule rather than the exception. This has freed the jeweler to explore any artistic style and technical realm. A new boldness in size and concept, once reserved for theatrical costumes, is now accepted as appropriate. Value is predicated more on the intrinsic appeal of the piece than on the preciousness of the materials from which it is constructed.

This book presents a repertoire of techniques in several media. Instructions are given in simple, readily understandable terms to minimize frustration and maximize learning. Tools and equipment are kept to a minimum to make projects accessible to those who must be conscious of financial constraints. While the book serves as an introduction to techniques, the bibliography presents suggested readings for more extensive study in a particular medium.

Tools and materials are chosen with regard to health and safety hazards. Wherever the possibility of such a hazard exists, warnings are indicated in **bold type.**

The jewelry shown on these pages represents the work of some of the most talented jewelers from the United States and other nations. They are offered as an inspiration, to demonstrate what can be accomplished with imagination, technical skill, dedication and a personal point of view. Multicultural and historical examples have also been included to show the universality of sources from which innovation and talent can spring. Warning: once you get started, you may find yourself totally absorbed in this most engaging and creative of activities. Beware! You may become a hopeless addict. It happened to me.

The Jeweler's Art

A MULTIMEDIA APPROACH

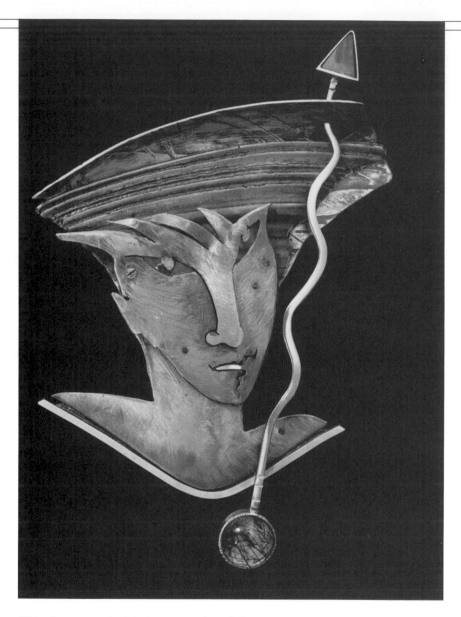

This piece, expressionistic in concept, is made by sawing, piercing and texturing. Enid Kaplan, *Pathfinder*. 14K gold, sterling silver, brass, niobium, lapis, tourmalated quartz, 4 x 2½ x ½" (10.2 x 6.4 x 1.3 cm). Photograph by Guy L'Heureux.

\mathcal{M}etal $\boxed{1}$

\mathcal{M}etal has long been the most popular jewelry medium. No other material offers such distinctive attractions to the jewelry designer. Metal is both durable and malleable. It can be polished to a high gloss and will accept a variety of surface treatments. Metal's intrinsic value has also contributed to its long-standing popularity.

When we look at the history of making jewelry from metal, we see human ingenuity exploited to its fullest. More techniques have been developed for making metal jewelry than for any other medium. Some jewelers choose to limit themselves to a few simple methods; others enjoy exploring the full range of options that metal offers. Whether jewelry designers use a basic technique in an understated, sensitive manner or decide to display a more daring level of technical facility, metal can be used to achieve a vast array of effects.

Brass, bronze, copper, silver and gold are popular metals from which to make jewelry. Each has a characteristic color and unique qualities. These are nonferrous metals (that is, they do not contain iron) and are available in sheet, wire and tube form.

The thickness of metal is measured by its gauge. The higher the gauge, the thinner the metal. Function as well as design should be considered when choosing the gauge suited for a particular piece of jewelry. The weight of the piece must also be taken into account if your goal is to create jewelry

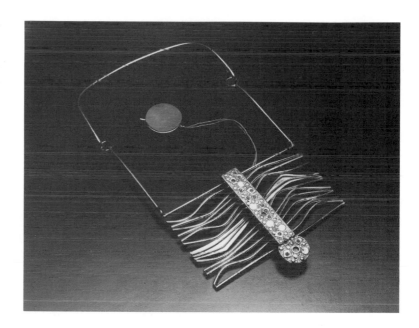

The earphone on this necklace monitors the heartbeat, introducing the element of sound into jewelry design. Mary Ann Scherr, *Body Monitor.* 14K gold, sterling silver and electronics.

that is functional and comfortable. For example, if you are fashioning earrings from sheet metal, you would probably want to use 20-gauge or thinner metal. A bracelet, on the other hand, should be constructed from a thicker gauge so that it can withstand the abuse it will inevitably be subjected to on the wearer's wrist.

Sawing

Intricate designs can be cut from sheet metal with great precision by sawing. Using a jeweler's saw and blades, you can cut any line that can possibly be drawn with a pencil. Jeweler's saw blades are thin and can break easily. Even a seasoned jeweler can break an occasional blade; the novice should expect to break several before mastering this technique.

Tools and Materials

All of the tools and materials needed for making metal jewelry can be purchased from a jewelry supply company (see Sources of Supply, *page 156).*

- **tracing paper**
- **pencil**
- **scissors**
- **sheet metal**
- **mallet**
- **6" (15.2 cm) steel rule**
- **glue stick**
- **scribe**
- **metal shears**
- **jeweler's saw and blades**
- **beeswax or Bur Life (optional)**
- **bench pin**

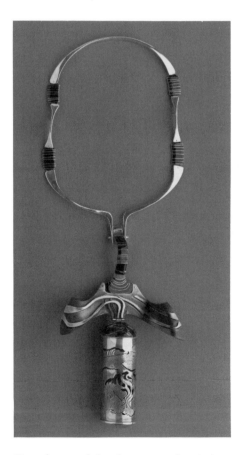

Forged, enameled and constructed neckpiece with a container. Pierced, sawed, enameled and engraved. Nilda F. Getty, *La Mer, Sea Creatures Series #3.* Sterling and fine silver.

Bolo tie. Cathleen Bunt. Pierced and sawed sterling silver with red coral.

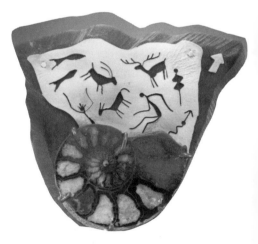

Based on the myth that civilization evolved from a shell in the ocean, the delicate animal and figure forms on this pin were pierced and sawed. Alice Van de Wetering, *The Beginning of the World,* 1991. Acrylic, sterling silver and ammonite fossil.

Preparing for Sawing

Begin by flattening the metal against an even surface with a plastic, wooden or rawhide mallet. These soft materials will not stretch or mar the surface of the metal. Do not use a steel hammer to flatten metal. Steel will leave dents that will be difficult to remove.

Cut a piece of metal slightly larger than your overall design. Use a scribe drawn along a small steel rule to incise a rectangle of the desired size. Cut along the incised line with metal shears; aviation shears work well for this.

Transfer your design onto tracing paper with a pencil. Use scissors to cut out the design, being sure to leave approximately ¼" (0.6 cm) of paper surrounding the design. You will be sawing directly through the pencil line.

Next, glue the paper onto the metal by covering both the back of the paper and the metal with a thin coat of glue stick. After they have been allowed to dry to a tacky state, press them firmly together. (If the paper is placed on the metal before the glue becomes tacky, it will not dry and will slide around while you are sawing.)

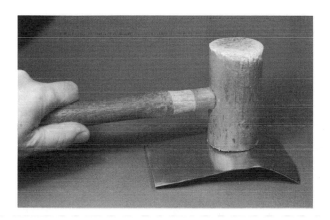

The metal is flattened with a mallet.

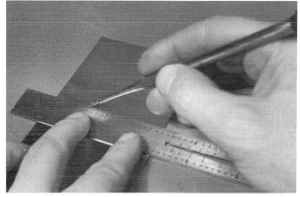

A cutting guide line is incised with a scribe drawn along a steel rule.

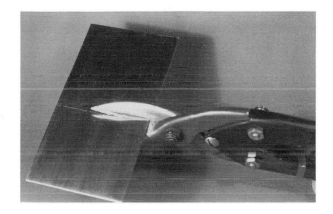

Shears are used to cut along the incised line.

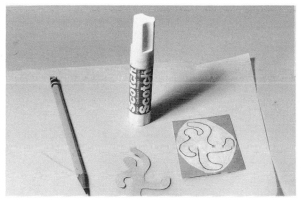

The paper template is traced onto tracing paper, roughly cut out and glued onto the metal with a glue stick.

To load the blade into the sawframe, tighten the blade in one end of the saw. Then, while the frame is pressed against the workbench, clamp the other end. When you release the frame from the bench, the blade will be taut and ready for sawing.

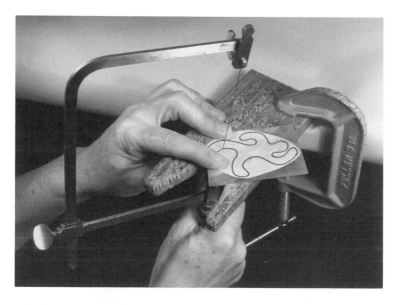

The design is sawed through the tracing paper and metal with a jeweler's saw.

Sawing Metal

Jeweler's saw blades are available in a range of sizes, from the finest (#8/0) to the coarsest (#14). A #1 or #2 blade is recommended for general use. A jeweler's saw can be adjusted to accommodate blades of varying lengths and has a clamp at both ends to hold the blade in tension.

To load the blade into the saw, insert it in one of the clamps with the blade's teeth facing down toward the handle and out and away from the saw frame. Tighten the thumbscrew (or, in some cases, the wing nut) until the blade is gripped firmly at one end. Adjust the height of the frame so that the blade lies just short of the other end. This small gap is necessary to maintain tension on the blade. Holding the handle in one hand, press the frame against the workbench until the blade slides up the clamp. Then tighten the clamp with the other hand and gradually ease the saw off the bench. When properly inserted, the blade will sound a high-pitched ring when plucked.

Before you begin sawing, you may wish to lubricate the blade by drawing a piece of beeswax or Bur Life along it. Using a bench pin clamped to the workbench to support your work, hold the metal firmly in place against the clamp so that it does not shift while you are sawing. This will help prevent blade breakage. Hold the saw perpendicular to the metal and gently draw the blade up and down. Excessive force is unnecessary and will only serve to break the blade and exhaust the jeweler. The blade cuts on the down stroke. Do not attempt to turn your work suddenly or while the blade is stationary; make changes in direction only while sawing. **SAFETY NOTE: Keep hands away from the line of cutting.**

If a blade should break in a manner that leaves most of it intact, it can be reused by adjusting the saw frame and reloading the blade as explained above.

Finishing

The shape and surface of the metal is refined by filing, sanding and polishing. Metal can be left unfinished, brought to a high polish or left at any point in between. This is a matter of individual preference. The rough texture of file marks may suit the general concept of the work better than the refined luster of a polished surface.

Tools and Materials

You will need to have the following tools and materials at hand when finishing metal.
- **files**
- **file brush**
- **emery paper (coarse, medium and fine grits)**
- **buffing and polishing compounds**
- **two polishing sticks (for hand polishing)**
- **electric polishing machine (for machine polishing)**
- **ammonia, liquid detergent and water**

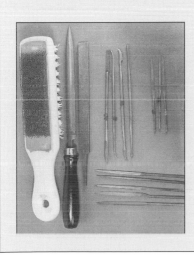

File cleaning brush and hand, riffle and needle files.

Filing

Files are used to refine and smooth edges and surfaces. This is the first step in a process that will eventually leave the metal as smooth and polished as desired. Files are manufactured in a wide variety of sizes, shapes and cuts designed to fit any contour. Large files are used for large surfaces; needle files work best for small surfaces. File shapes include round, half-round, square, triangular and flat. The *cut* of a file refers to its coarseness. Coarse files are designed to quickly remove metal, while finer files will effect more gradual changes. Work from coarser to finer files.

Files cut most efficiently on the forward stroke. File away from your body and lift the file slightly off the metal on the back stroke. This will conserve energy and prolong the life of your file. Clean files periodically with a metal file brush to keep them from becoming clogged.

The edge of the sawed piece is refined by filing.

Sanding

Although it is tempting to minimize the tedious task of sanding, in the long run thorough sanding will save time and energy. Emery paper will replace marks left from filing with finer scratches. As you work your way from coarse to fine grades of emery paper, the scratches will eventually become so fine that the metal looks almost polished.

Begin by working from the coarsest grade abrasive to finer grits, sanding any areas that need refinement. Many jewelers start with a coarse grit (#240), proceed to a medium grit (#320) and finish with a fine grit (#400). If a shiny surface is desired, use #600-grit emery paper. Choose the grades that best meet your individual needs. Abrasive paper or cloth can be easier to work with if it is supported on a stick, block or dowel. Once you have used grit #400 or finer, you are ready for buffing.

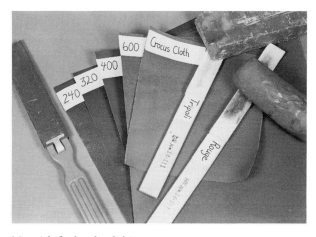

Materials for hand polishing.

Buffing and Polishing

Buffing removes any scratches left by sanding and prepares the metal for polishing, which imparts a high shine to the surface. Both processes can be accomplished by hand or by machine.

Hand Buffing or Polishing

For hand buffing, use a polishing stick to which a buffing compound (such as tripoli) has been applied. Rub the compound against the felt side of the stick. You can either make your own polishing stick by gluing a piece of felt or suede onto a flat stick or purchase one ready made from a jewelry supply company.

If you wish to impart a high polish to the surface, polish with rouge after buffing with tripoli. Use a separate stick for each compound.

Between compounds, clean the work in water to which dashes of ammonia and liquid detergent have been added. **SAFETY NOTE: Use this solution in a well-ventilated area.** Clean the work again when you have finished polishing.

Machine Buffing or Polishing

Although polishing by hand is safer, requires less of a financial investment and is more precise, most jewelers opt to save time and energy by using an electric polishing machine. Polishing machines are fitted with two tapered spindles with buffs. The buffs are often made of muslin, although other materials such as wool and felt are also used. Each buff is charged with a separate compound by pressing the compound against the wheel as it is spinning. Do not overcharge the wheel or it will become clogged and will not work efficiently.

When buffing or polishing, the metal is held firmly in position in front of the lower front portion of the buffing wheel. Since the wheel spins counter-clockwise, work that is accidentally dropped will be flung into the machine rather than

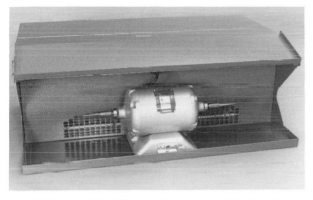

A polishing machine. Photograph courtesy of Frei and Borel.

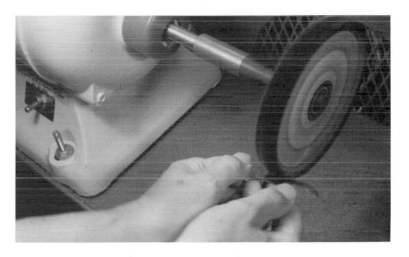

The piece being polished is held firmly in both hands at the lower front portion of the buffing wheel.

at the worker. **SAFETY NOTE: Polish chain by hand. If using a machine, wrap the chain securely around a board for support. Do not polish a loose chain or it will catch on something and be flung around.**

The material from which the buffs are made, as well as the type of compounds used, are matters of individual preference. The two compounds mentioned previously—tripoli and rouge—are frequently used. Some jewelers use a third compound—bobbing—prior to buffing with tripoli. Bobbing is a coarser abrasive and will cut metal quickly. Be careful not to distort the form by using too much bobbing. For an even finish, turn work periodically while buffing and polishing.

SAFETY NOTE: A polishing machine should be fitted with a dust collector or exhaust system to minimize the amount of airborne compound. Wear a NIOSH-approved dust mask and goggles when buffing and polishing. Tie hair back and do not wear loose clothing or jewelry while operating the polishing machine.

Another machine used for polishing is the flexible shaft. Its smaller versions of the polishing wheels are tightened in the handpiece. This machine is particularly useful for working on hard-to-reach areas. Drill bits, burs and bristle and wire brushes can also be used in the flexible shaft.

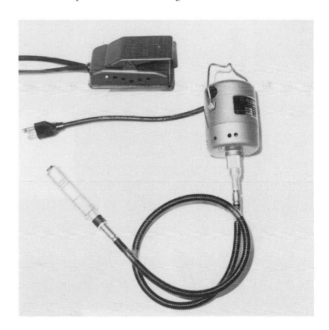

A flexible shaft machine. Photograph courtesy of Allcraft Tool and Supply Company.

When you have finished polishing, clean the work in a solution of warm water to which dashes of ammonia and liquid detergent have been added. **SAFETY NOTE: Use this solution in a well-ventilated area.**

Drilling and Piercing

A hole can be drilled for many purposes, including decoration, accepting a jump ring or rivet, or piercing a shape from the interior of the sheet metal. For piercing, the hole is drilled to accommodate the saw blade.

Before drilling, use a center punch to make a shallow dent in the metal that will accept the drill bit and keep it from skipping out of place. One type of center punch is hit with a hammer; the automatic punch is activated by hand pressure. When using a center punch, support the work on a metal surface. This will prevent distortion of the metal (see figure below center).

To drill the hole, use a hand drill or a drill press into which the appropriately sized bit has been tightened. Choose a bit large enough to accommodate the saw blade. Support the metal on a block of scrap wood to protect your bit and the work surface. Drill perpendicular to the metal (see figure below right).

After drilling, insert the blade—with one end already tightened in the frame—through the hole that you have just drilled. Then tighten the other end of the blade until the proper tension has been achieved (see *Sawing Metal*, page 6).

After you have finished sawing your interior line or shape, open the clamp at one end and slip the saw blade out of the hole.

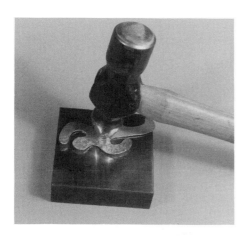

Texture is applied to the surface with a ball-peen hammer.

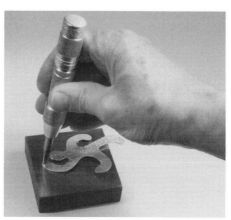

An automatic center punch is used to make an impression in the metal where the hole will be drilled. This prevents the drill bit from jumping and marring the surface.

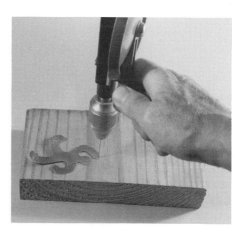

The hole is drilled with a hand drill.

Stamping

Stamps and other tools can be used to create a design, pattern or texture on a metal surface. While commercially manufactured stamps are made specifically for this purpose, stamps can be made by hand or created from other objects.

A stamping tool is a steel rod with a design filed or carved at one end. When the rod is struck with a hammer, the design is transferred to the metal surface. Tools that leave interesting impressions include punches, dapping tools or even the head of the hammer itself. A large nail can be filed to create a personalized stamp. Try using a center punch, screwdrivers, alphabet stamps, chasing tools—virtually any tool that can withstand the blow of the hammer.

Tools and Materials

You will need the following tools and materials at hand when stamping metal.

- **chasing hammer**
- **variety of stamping tools**
- **polished steel block**

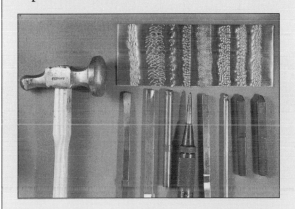

Tools for texturing include chasing and stamping tools, a center punch, a matting tool, a dapping punch and letter stamps.

The markings on these six pins are stamped with a variety of tools, including alphabet stamps. Peggy Johnson, HouseWearables®. *Tea Time*. Sterling silver and copper. Photograph by Peter Groesbeck.

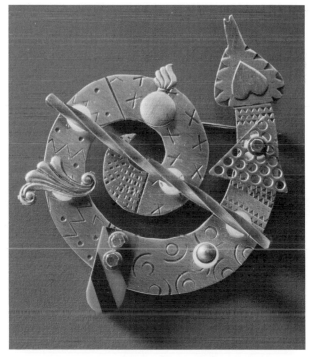

A pin with stamped markings. Thomas Mann, *Collage Snake Pin*. Nickel, bronze, brass, stainless steel and laminate plastic. Photograph by Bob Barrett.

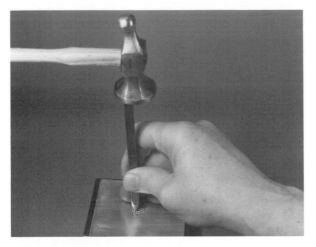

The texturing tool is hit with a chasing hammer.

When you have gathered several stamping tools, try them out on a piece of scrap metal. Support your work on a steel plate so that the stamped image will be well defined. It is helpful to steady the hand that is holding the punch by bracing it on the work surface.

Hold the stamp perpendicular to the metal and strike the head with a firm blow of the chasing hammer. Since chasing hammers have particularly large heads, it is easy to hit your mark. Such hammers are used only to hammer steel tools, so you need not be concerned about the marks that appear on its face.

Stamps may be used to make multiples of an image. Try rotating the punch, superimposing stamped images and making rows or borders of a repeated image.

The texture on this surface was created by hammering the metal directly on concrete. Mary Ann Scherr, *Necklace*. Sterling silver.

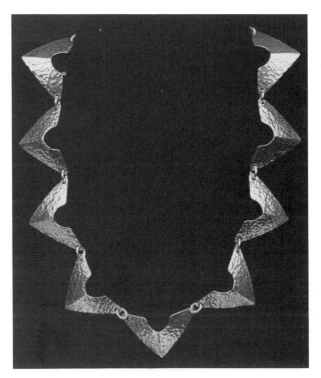

Necklace composed of segments that are cut, punched, bent, and textured with a small, ball-peen hammer. David Luck. Sterling silver.

Annealing

Whenever metal is worked—whether by hammering, bending, filing, twisting, burnishing—it becomes work-hardened and gradually loses its flexibility. For example, when metal is hit repeatedly with a hammer, the hammer will eventually bounce back without moving the metal; or forged wire will become resistant to bending. The more you work, the more brittle the metal will become. If worked too long, the metal will break. (You may have observed this process occurring when you repeatedly bend wire until it cracks.) Through trial and error, you will learn to judge when metal is too hard to work efficiently.

It is sometimes desirable to use work-hardened metal. Work-hardened wire has more spring to it, making it ideal for pin stems, for example. In most cases, however, work-hardened metal is difficult to work with. Annealing work-hardened metal restores its flexibility.

To anneal, place the metal on an annealing pan. This is a circular pan, filled with pumice lumps, that can be easily turned to provide access to the work from all angles. Using a torch, heat the metal evenly to its ideal annealing temperature. This temperature is unique for each metal.

Because metals change color when they are heated, you can determine when a particular metal has reached its proper annealing temperature by observing its color. Sterling silver and yellow, red and green gold, for example, are annealed when

Tools and Materials

You will need the following tools and materials at hand when annealing metal.

- **annealing pan**
- **torch (see page 28 for cautions)**
- **paste flux (see page 28 for cautions)**
- **soldering tweezers**
- **pickle**

they take on a dull red color. Brass is annealed when it turns light red. Copper, bronze, NuGold and white gold turn cherry red when they have reached their annealing temperature. Because these color changes can be difficult to see in a well-lit room, many jewelers prefer to lower the lights and anneal in semi-darkness. Be careful not to overheat the metal, as it will melt.

Another way to determine when sterling silver is ready for annealing is to paint it with Handy Flux. When this milky paste becomes clear, the silver has reached the proper temperature for annealing.

Before annealing wire, first wind it in a tight coil. This will prevent the wire from melting by distributing the heat evenly rather than allowing one section of wire to overheat and melt.

When the metal has cooled to the point where it is no longer red, it can be quenched in pickle.

Pickling

Metal is soaked in a pickling solution before and after soldering to remove dirt and the effects of oxidation.

Although there are many different pickling solutions used by jewelers, Sparex is recommended as a safer alternative to highly caustic solutions such

as sulfuric acid. Mix Sparex with water in the proportions indicated on the label. Its efficiency is greatly increased when it is heated. An electric, ceramic-lined Crockpot is excellent for this purpose. Crockpots can be purchased at any store that sells cookware. A similar product called an *electric*

pickler can be purchased from a jewelry supply company.

Use copper tongs to remove work from the pickle. Never introduce iron into the pickle.

SAFETY NOTE: Do not allow the pickle to boil. Avoid contact with skin. Cover the pot after use. Use in a well-ventilated area. Rinse objects well in running water after pickling.

Twisting Wire

Wire adds the element of line to the jeweler's visual vocabulary. Metal wire is available in many thicknesses as well as shapes. Round, square, rectangular, triangular and even patterned wire can be purchased from a jewelry supply company. Brass, bronze, copper, silver and gold each have a distinctive color that can be used to decorative advantage in twisting. Different thicknesses of wire and several metals can be combined by twisting to create a wide variety of patterns and decorative effects. The possibilities are endless.

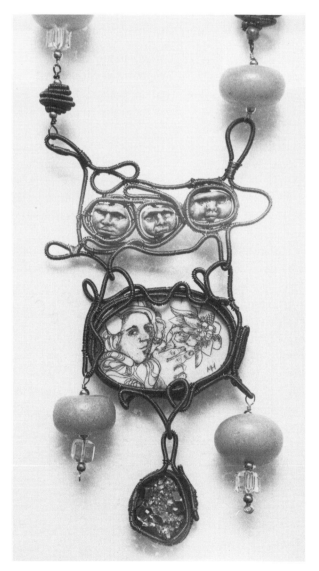

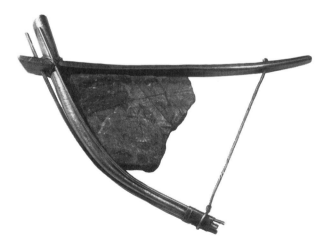

The cable that creates visual tension on this pin is made from twisted wire. Harold O'Connor. 18K and 24K gold and spectrolite.

Coiled necklace. Marylou Higgins. Magnet wire, ceramic clay, scrimshaw on antique ivory, pyrite, and amber and crystal beads. Photograph by Edward Higgins.

Tools and Materials

You will need the following tools and materials at hand when twisting wire.

- **wire**
- **wire cutters**
- **mallet**
- **bench vise**
- **hand vise (for thick wire)**
- **hand drill with a cup hook tightened in its chuck (for thin wire)**

Wire cutters. (a) End cutters and (b) side cutters.

Wire is twisted with one end held in a cup hook tightened in a hand drill and the other end clamped in a vise.

If a single strand of round wire is twisted, it will not change shape. Some wires (square wires, for example) can be twisted as a single strand to produce a visual twist. Wires can be twisted together and then combined with other wire and twisted a second time.

Wires used for twisting should be cut with wire cutters and annealed so that they are soft and easy to twist (see *Annealing,* page 13). It is not necessary to anneal thin wires.

To twist two wires, cut two equal lengths of wire. Clamp one end in a bench vise and the other in a hand vise. Pulling gently on the wires to keep them straight, twist the hand vise until you have achieved the desired degree of twist. A single strand of thin wire can be folded in half and the loose ends clamped in a vise. The bent end is held in a cup hook that is clamped in the chuck of a hand drill. Turn the drill handle while maintaining gentle tension on the wires and the wire will twist.

Thick, twisted wire can be flattened with a hammer. Do not hammer wires so much that they cut into one another and weaken the structure to the point where the wire is in danger of breaking. Twisted wires can be used to make bangle bracelets or as decorative elements.

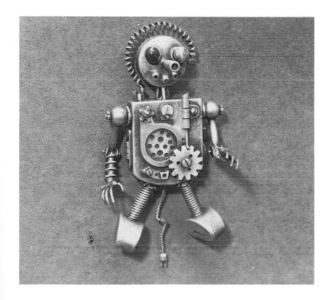

Elements of this pin are made from coiled and twisted wire. Earl Krentzin, *Robot.* Sterling silver, 18K gold, rhodonite and epidote.

Bending Wire

The most efficient wire-bending tools are your hands. They leave no marks and can subtly control the form. Sometimes, however, hands are not strong enough or are too large to bend delicate curves. This is when pliers can be useful. Pliers are manufactured in many shapes, including round, flat, forming, half round and chain nose. Choose pliers with jaws shaped to correspond to the curve you want to bend.

Jeweler's pliers are smooth jawed to minimize marking of the metal. If you purchase new pliers, you may wish to dull their sharp edges by filing and polishing. This will prevent the pliers from cutting into your work and making unwanted marks. Use a separate file for the filing of steel. Lea is a polishing compound that can be used for polishing steel tools.

It is wise to bend a curve properly the first time, since it is difficult to straighten a wire completely after it has been stretched into a curve. When possible, experiment first with inexpensive wire and, when satisfied, execute the final design in the metal of choice. A mallet may be used to straighten thick wire. Thin wire may be clamped at one end in a bench vise and held at the other end in a hand vise or pliers and pulled straight.

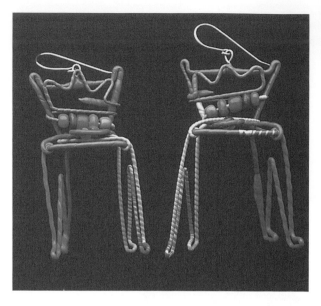

Designed in bent wire covered with paint, the artist has injected an element of playfulness into these earrings. Anne McFaul Reid, *Chairs*. Paint, glass beads and wire.

In addition to bending wire with pliers, wire and sheet metal can be bent with a mallet over an edge of a metal or wooden form such as a table. The mallet will force the metal to shape without distorting it.

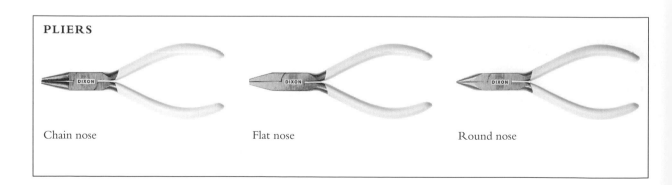

PLIERS

Chain nose Flat nose Round nose

Forging Wire

Although seemingly a rigid, resistant material, metal is actually quite plastic and is easily sculpted into organic, flowing forms through the process of forging. As a line drawn by the calligrapher flows from thin to thick, so wire—the linear element in jewelry making—can be hammered to alter its width. Applying the proper degree of force to the right spot takes skill, but with a little practice, a piece of ordinary metal can be transformed into an elegant, sculptural work.

Tools and Materials

You will need the following tools and materials at hand when forging wire.

- **annealed metal**
- **mallet**
- **anvil, stakes and/or a polished steel surface plate**
- **forging hammers**

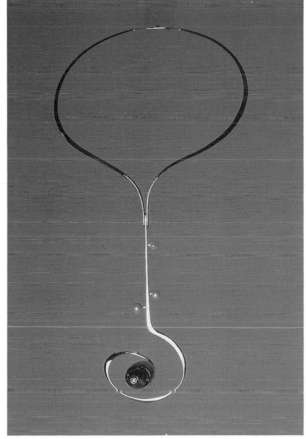

Above: This neckpiece is composed of simple, flowing lines of forged wire. Sigurd Persson, 1982. 18K gold wire, black and white pearls.

Right: Neckpiece. Sigurd Persson, 1973. Forged 18K gold wire and fresh water pearls.

Preparing the Metal

Before metal can be efficiently forged, it must be softened to minimize resistance. When you purchase metal, it is often pre-annealed. You will know that the metal is too hard to work when the hammer bounces back and does not make a significant impact on the surface. This will occur gradually as you forge and the hammer blows compact the molecules and prevent them from moving around easily. Metal that is not annealed will become brittle and will eventually crack (see *Annealing,* page 13).

The Work Surface

Forging is done over a flat or curved steel surface, depending upon the shape you desire in the finished product. Anvils and stakes come in many sizes and shapes. Forge flat work over the flat section of an anvil or on a steel surface plate. It is essential that both the hammer faces and the supporting surface be highly polished. Any imperfections in these surfaces will be transferred to the metal with each blow of the hammer.

Forging Hammers

If you look through a jewelry supply catalog, you will notice that there are a variety of forging hammers available. The faces of these hammers are quite varied in shape and size. Each will form the metal differently. Many jewelers shape the heads of their hammers for specific purposes by filing and polishing them. (Keep files used on steel separate from jewelry-making files.)

One forging hammer, the cross peen, has a face that runs perpendicular to the hammer's shaft. The cross-peen hammer stretches the metal in a direction parallel to its shaft. When struck perpendicular to the length of the wire, the metal will become

HAMMERS

Forming

Ball peen

Cross peen

Planishing
Photographs courtesy of Allcraft Tool and Supply Company.

When forging, it is important to strike the metal squarely. Wire that is hammered at an angle will curve toward the opposite side as the metal compresses more on one side. By turning the wire over and hammering again at the same angle, a curve can be straightened. A mallet can be used to help straighten gentle curves. Unlike a hammer, a mallet will not dent or stretch the metal.

A planishing hammer is used to both forge metal and smooth out hammer marks. It has one flat and one slightly convex face. This hammer spreads the metal in all directions, away from the center of the face. A wire that has been bent in a design can be widened by hammering it at strategic points.

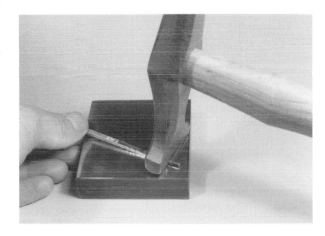

A cross-peen hammer is used to forge wire in a direction parallel to the shaft of the hammer.

longer and narrower. Square wire should be rotated regularly one quarter of a turn between hammer blows to keep it square. (Round wire can also be made square in this manner.) Wire can be tapered by hammering in progressively greater amounts as you work down its length. (A thick rod can be tapered to a fine point in this manner.)

Forging a Fibula

A fibula is an ancient form of jewelry shaped something like a safety pin. It was originally used to fasten clothing. Many different forms of the fibula have appeared throughout history, including several modern versions.

Fibula with Band of Four Water Birds, circa 1350–1050 BC. Italic, bronze. The Metropolitan Museum of Art, Fletcher Fund, 1926.

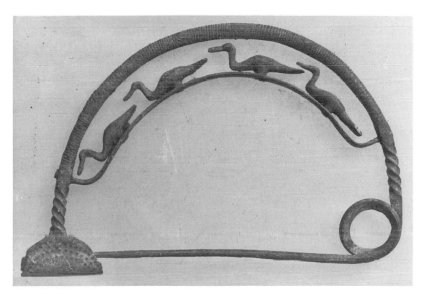

The Jeweler's Art

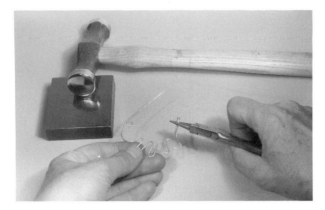

The wire is bent with pliers to create the basic design of this fibula.

Tools and Materials

You will need the following tools and materials at hand when forging a fibula.

- **wire**
- **wire cutters**
- **pliers**
- **steel surface plate**
- **mallet**
- **cross-peen hammer**
- **planishing hammer**
- **materials for finishing metal (see *Tools and Materials*, page 7)**

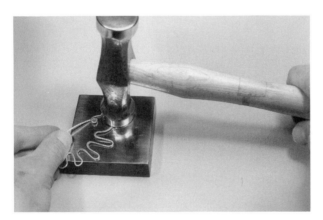

A planishing hammer will spread the metal in all directions from the center of the round head.

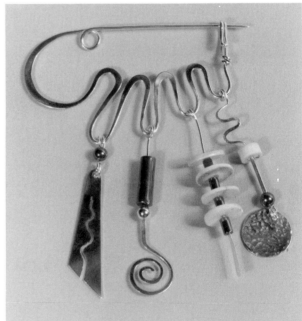

The completed fibula.

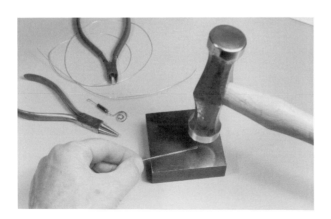

The end of the wire can be forged wider to hold a bead in place.

A fibula can be made from a single piece of wire. Decorative elements, such as beads and wire, can be hung from it. Materials can also be lashed onto the fibula with wire, or a technique called *coiling* can be incorporated into the design (see *Coiling, below*). Making a fibula is a good introduction to the techniques of bending and forging wire.

Before you begin working in wire, make several line drawings of your fibula designs. The functional part of the pin should be an integral part of the design. Experiment with forging on scrap or inexpensive wire before working on the final piece.

If you are using wire that is too thick to function as a pin stem, begin by thinning a length of wire with the cross-peen hammer. Working on a steel surface plate, taper the pin stem so that it can easily be inserted into fabric. If necessary, use a file to further point the tip.

Bend the wire in a circle at the base of the pin stem to create a small spring to hold the stem tightly in its catch. The catch is made by bending a hook at the opposite end of the wire. Between the stem and catch is the decorative portion of the pin.

It can be bent in any configuration and its width can be varied by forging with the planishing and cross-peen hammers.

When possible, make bends in the wire by hand; pliers of the appropriate shape can also be used to form the bend. Depending upon the complexity of the design, you may wish to forge the wire and then bend it, or to first bend and then forge. Remember that forging changes the length of the wire, so plan accordingly.

To add hanging beads on a short length of wire, first use a planishing hammer to flatten the end of the wire, thus creating a stop to prevent the beads from falling off. Next, string the beads onto the forged wire. Attach the beaded wire to the fibula by looping the unforged end around the pin with the aid of round-nose pliers. Make certain that the loop wraps at least one and one-quarter times around so that it will not fall off. Holes can be drilled and objects hung from areas that are forged thick enough to accept a hole without weakening the structure.

Finish the piece by filing, sanding and polishing.

Coiling

Coiling is a basketry technique that can be adapted to working in wire. A core of wire curved in a design is wrapped with a thinner wire, called the *weft*. To connect one row of coiling to another, a stitch is taken with the weft at regular or irregular intervals. A strong, stiff form can be coiled from thin, fragile wire. The process of coiling is an organic one in which the structure grows as you work.

In coiling, the weft must be flexible enough to be wrapped tightly around the core. Although coiling is generally associated with materials such as reed and cord, wire is ideal for this technique.

Tools and Materials

You will need the following tools and materials at hand when coiling wire.

- **two or more gauges of wire**
- **wire cutters**
- **scribe**
- **pliers**
- **beads (optional)**

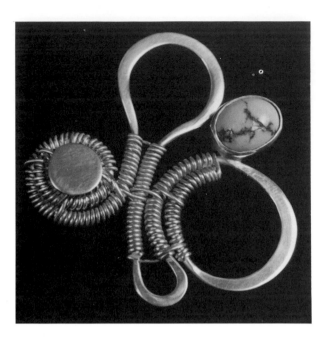

Coiled pin. By the author. Sterling silver, 14K gold and turquoise.

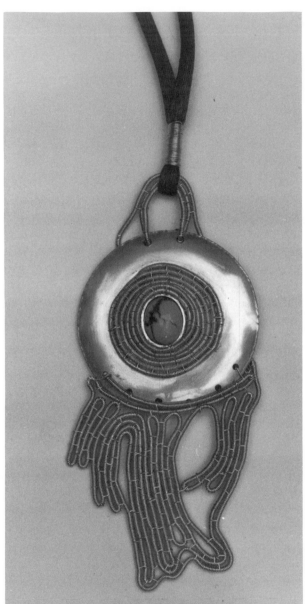

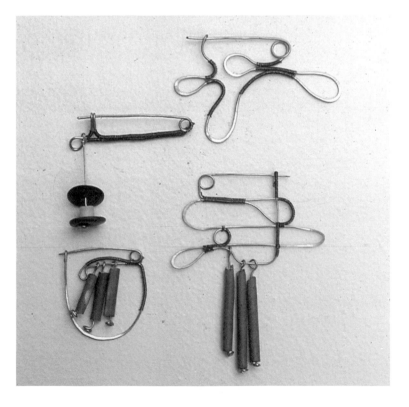

Above: Coiled pendant. By the author. Sterling silver, fine silver and turquoise.

Left: Student experiments in coiling. Thin color-coated copper motor wire was used for the weft.

Wire not only obediently holds its shape however you bend it, but also acts as its own needle. Fine silver, gold and copper are particularly malleable metals and are quite suited for this purpose. Less malleable metals can also be used if they are not too thick. The core can be made of a single wire or several wires, and is thicker than the weft. It should be strong enough to support the coiling process yet flexible enough to bend with ease.

The core need not be covered completely by the weft. Areas may be left exposed or even forged (see *Forging,* page 17), thus giving shape to the coiled line. Variations can also be achieved by varying the size of the wires, by stringing beads onto either the core or the weft as you work, and by using different metals to add color and pattern to the piece.

Begin coiling by cutting wires for the core and weft with wire cutters. Hold the thicker wire (the core) in your weaker hand and begin wrapping the weft around the core with your stronger hand. Where necessary, use pliers to keep the coils even and tight. Bend the core in whatever configuration you wish as you work; this is how you create the design. Take a connecting stitch with the weft around the previous row at regular intervals. If the coils are too close together to allow the wire to pass between them easily, use a scribe to spread the coils and make room for the weft.

If you run out of weft, simply begin wrapping a new piece of weft where the old one ends. Try to plan ahead so that you do not run out of core. However, if you do need to add core, file the ends of both the new and the old cores to a taper so that the two tapers blend together to make a single thickness when they overlap. Wrapping over this joint may be sufficient to bind it, but you may have to solder it (see *Soldering,* page 28). This will depend upon the size and design of your piece and the length of the taper.

To make a pendant, incorporate a loop for hanging into your design. A necklace can be fashioned with a hook-and-eye clasp as an integral part of the

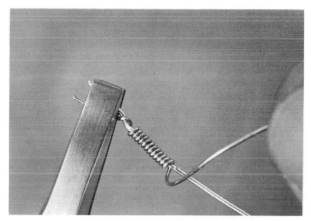

Begin coiling by wrapping the weft around the core.

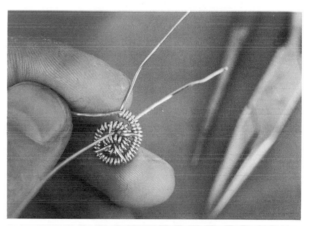

Use the weft to take a connecting stitch in the previous row at intervals.

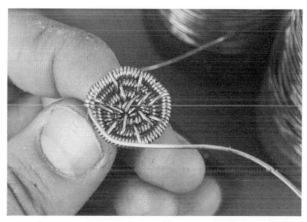

To make a concave form, wrap the core and take connecting stitches as described in the text while pulling the core so that it rests partially on top of the previous row.

coiled design. A cuff bracelet can be made by coiling a design of bracelet length that is strong enough to retain its shape when it is worn. If the core is not thick enough to give the bracelet strength, it must be fortified by tight coiling with many connecting stitches taken at short intervals.

In addition to coiling, other fiber techniques, such as crocheting, knitting and weaving, can be applied to the making of jewelry. The book, *Textile Techniques in Metal for Jewelers, Sculptors, and Textile Artists*, by Arline M. Fisch, is an excellent resource in this field.

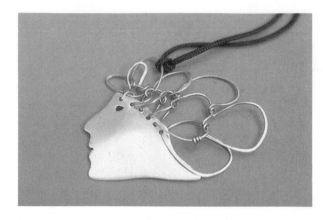

Pendant incorporating crocheted wire. By the author. Sterling silver.

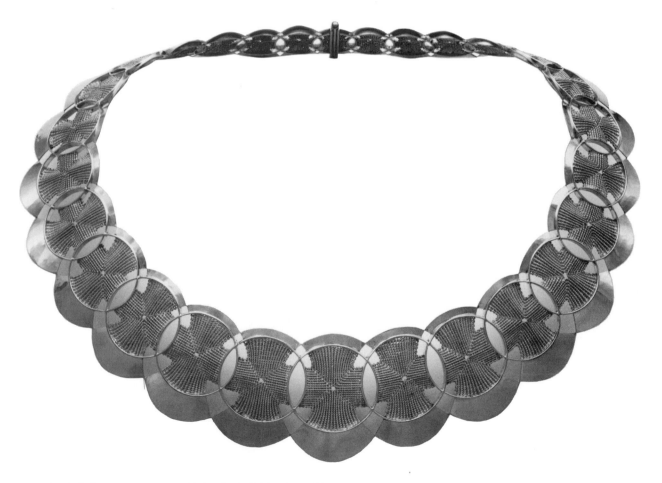

Twined choker. Mary Lee Hu. *Choker #78*, 1991. 18K and 22K gold.

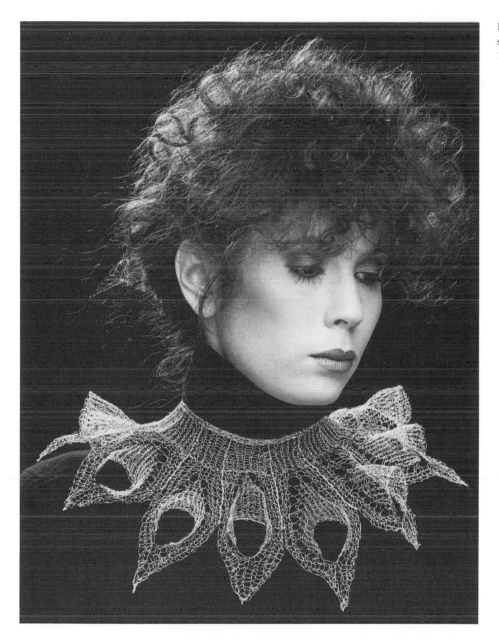

Hand-knit collar. Arline M. Fisch, 1985. Fine silver, 18K gold flat wire accents and clasp, 14 x 5" (35.6 x 12.7 cm).

Hammer-Forming Sheet Metal

In addition to changing the shape of wire, it is possible to form sheet metal with a hammer. This is accomplished by hammering the metal while holding it over an appropriately shaped stake.

Stakes are made from hard wood, plastic or polished steel. They can be used as purchased, or cus-tomized by the jeweler to conform to any size or shape. The following photographs demonstrate how jeweler and sculptor David Luck forms a bracelet.

A 6" (15.2 cm) bracelet blank is cut with shears from an 18-gauge sterling silver sheet. The edges are filed smooth.

The cut blank is divided with layout lines drawn in permanent marker. These lines will later become ridges.

This stake and hammer were reshaped by the jeweler to adapt them to his specific needs. The hammer has been rounded and ground narrower to better fit the stake grooves.

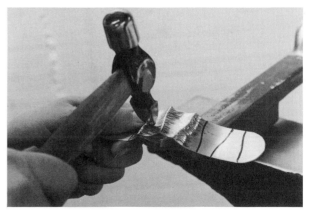

The valley and ridges of the stake are used to form the bracelet.

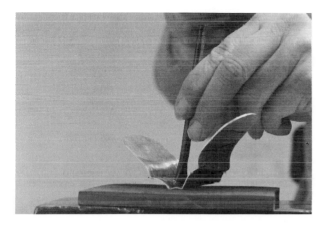

As the work progresses, the ridges may be accentuated and sharpened by hammering them from behind with a wide chasing tool. In this photograph, a rubber pad is used on top of the steel.

After the ridges have been formed, the bracelet is hammered again to refine the form and even out the overall hammer-peened texture.

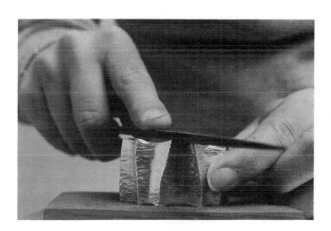

The edges are filed and then sanded smooth.

The completed bracelet. (These process photographs were taken by David Luck.)

Soldering

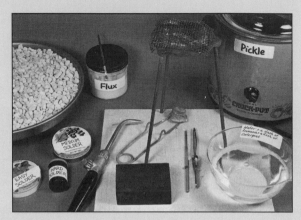

Materials for hard soldering.

One highly effective way to join metal to metal is by hard soldering. The high temperature needed for hard soldering (as opposed to soft soldering, which requires a much lower temperature) results in a strong joint.

Torches Used for Soldering

The soldering irons used for soft soldering do not provide nearly enough heat for hard soldering, which requires a torch. There are several types of torches, each of which burns a different kind of gas or combination of gases at various temperatures.

Propane torches with disposable tanks are adequate for small work, are inexpensive and can be purchased at a hardware store. They should be fitted with a pencil tip for jewelry making. These torches can also be fitted with rubber hoses for convenient handling. Their tanks are small and disposable.

Acetylene torches are more versatile and will reach higher temperatures than small propane torches. Their refillable tanks are larger and will therefore last much longer. In the long run, they are more economical. Several different sizes of tips are available for acetylene torches, which use Prest-O-Lite B tanks.

Other torches, including natural gas/air, oxy-acetylene and oxy-propane, are also used by jewelers. **SAFETY NOTE: Torches must not be placed in positions where they can fall. Chain torches to stable objects. Keep them away from heat and fire. Check for leaks with soapy water: bubbles will form if gas is escaping. Do not keep a leaky tank indoors.**

Soldering is done on a fireproof surface. Several materials are manufactured for this purpose. **SAFETY NOTE: Use only nonasbestos materials. Never use asbestos in any form.**

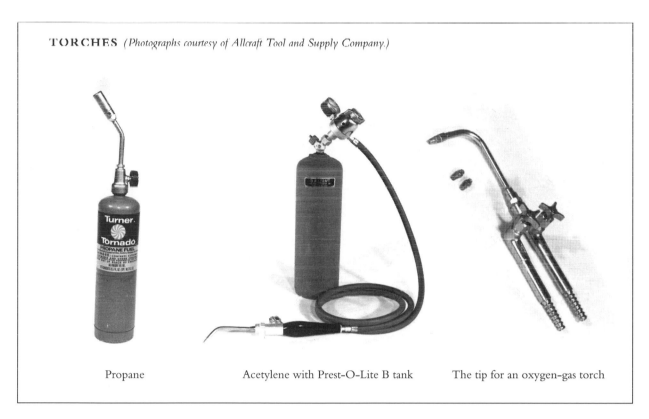

TORCHES *(Photographs courtesy of Allcraft Tool and Supply Company.)*

| Propane | Acetylene with Prest-O-Lite B tank | The tip for an oxygen-gas torch |

Solder

Solder is made from an alloy of metals. It melts at a lower temperature than that of the metals being soldered and thus bonds them together. Hard solder is available in several different melting points, including hard, medium and easy. They are used successively on pieces that require multiple soldering operations. For example, medium solder is used before easy solder because it will not flow when the easy solder is melted at a lower temperature during a second soldering operation. Should a piece require three soldering operations, hard solder would be used first, then medium, and finally, easy. Silver solder can be used to solder brass, bronze, copper, silver and gold. Gold solder is also available.

Solder comes in a variety of forms, including wire and sheet. Wire solder is cut with wire cutters or small shears. Wire solder is sometimes fed straight from the coil without cutting. Sheet solder is cut into tiny squares (called paillons) with small shears. A very small amount of solder is needed to make a strong joint. **SAFETY NOTE: Use only cadmium-free solder.**

Fluxing

Flux is used to augment the flow of the solder. It prevents oxides from forming on the heated metal surface. Flux is applied to the area being soldered, or even the entire piece, with a small inexpensive brush. It is reapplied each time the piece is re-heated. When soldering, work as quickly as possible, since prolonged heating will destroy the protective properties of flux. Handy Flux is one brand of flux that is used by many jewelers. **SAFETY NOTE: Use only fluoride-free flux.**

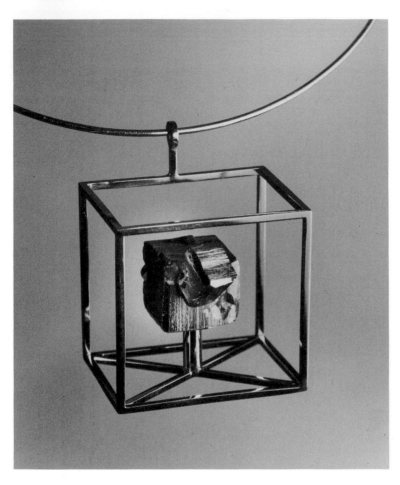

Pendant with cage form made of square wire that has been butt soldered. Sigurd Persson, 1973. 18K gold with pyrite.

Butt Soldering

In butt soldering, two pieces of metal are joined end to end without overlapping. To ensure a strong joint, the metal pieces should be cut or filed flush with one another. Solder will not fill gaps.

Begin by pickling and then rinsing the metal pieces to be soldered. Position them on a flat soldering surface, making sure that the joints fit squarely together. Flux all surfaces with a small brush. Lay the solder directly on the seams. Use tweezers or a small brush that has been moistened with flux to position the solder. Avoid the time-consuming process of later having to file off excess solder by using as little solder as possible. Novices have a tendency to be too generous when applying solder. Use a soldering pick to reposition any solder that becomes dislodged during soldering.

With the solder in place, heat the metal evenly with a torch, keeping the tip of the flame's inner cone near, but not touching, the metal. After briefly heating the entire piece, concentrate the heat at the point of soldering. The thin solder will melt easily, but the metal surrounding the solder must also be heated to the flow temperature of the solder. It is therefore important to direct the flame toward the metal rather than the solder, so that all elements reach the desired temperature simultaneously.

Experience will teach you how much heat is required and where to direct the flame. Large pieces of metal need more heat to bring them to temperature than small pieces. Remember that solder is attracted to heat and will flow towards it. A soldering pick is useful for coaxing molten solder over a seam.

Remove the torch immediately after the solder flows to prevent the metal from melting. The solder will solidify within seconds and you will be able to use your tweezers to move the soldered piece. Use copper tongs to place the work into the pickle for cleaning.

If necessary, file off any excess solder. Then sand with emery paper, polish and clean.

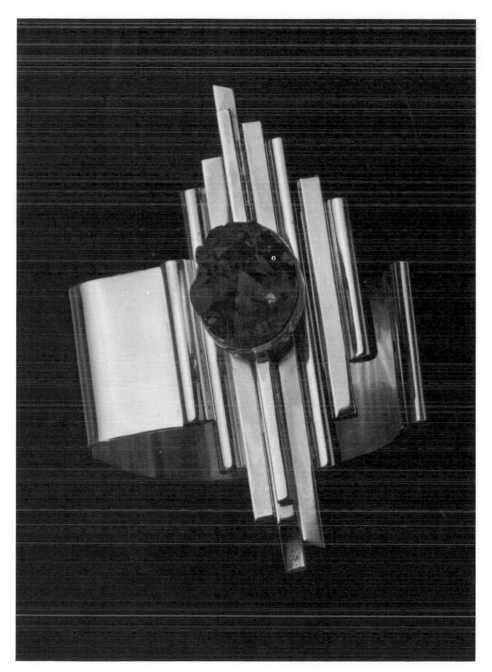

Tubes and sheet were butt soldered to create this cuff. Panchita Carter. Sterling silver and amethyst crystal. Photograph by Mark Fitzgerald.

The pieces are sawed and filed for butt soldering.

The metal is coated with flux. Small pieces of solder are applied with a brush.

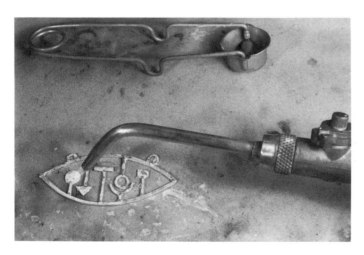

A torch is used to melt the solder.

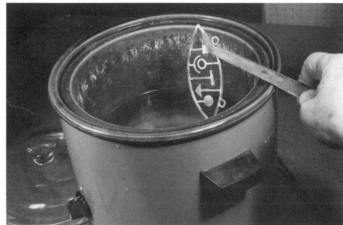

The piece is cleaned in warm pickle.

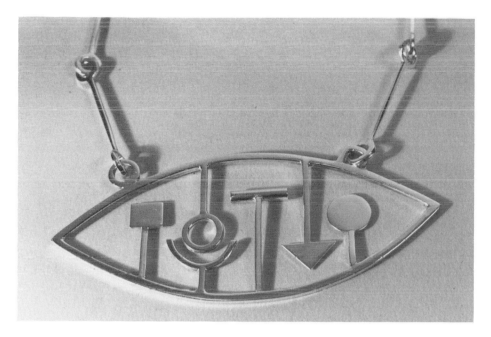

The completed piece.

Butt-soldered pins. Peggy Johnson,
HouseWearables®. *Garden Tools*. Sterling sil-
ver. Photograph by Allen Bryan.

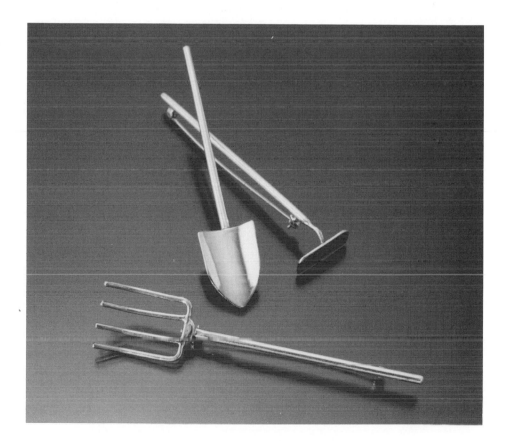

Sweat Soldering

Sweat soldering is a technique in which two layers of metal are soldered, one on top of the other, with a layer of solder melted in between. A tripod is used to support the work while it is being heated, thus allowing access from below. The solder is first melted onto the back of the top metal piece. A soldering pick is used to spread the molten solder evenly over the entire surface. The solder-backed top sheet is then placed in position over the bottom sheet.

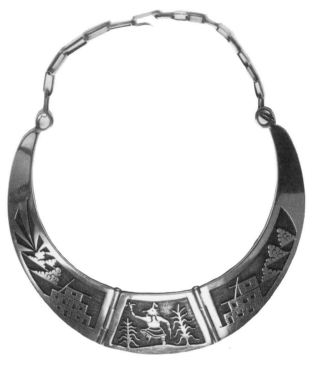

Sweat-soldered necklace. Native American (Hopi). From the collection of Eleanor Honig.

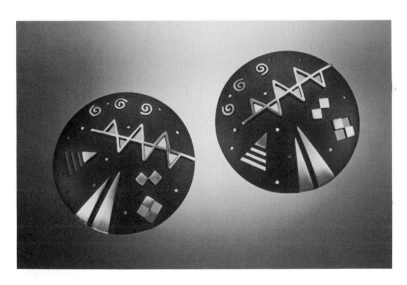

Earrings. Cathleen Bunt. Oxidized sterling silver.

Right: The floating shoes on this pin have been sweat soldered to the background. Roberta Williamson, *Tess and Ted*, 1992. Sterling silver, antique tin button and brass.

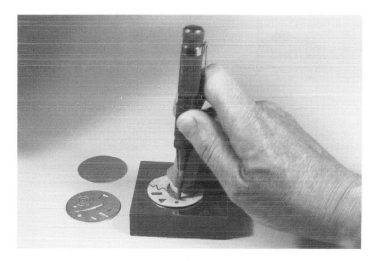

A center punch is used to make an indentation in the metal so that the drill will not jump and scratch the piece.

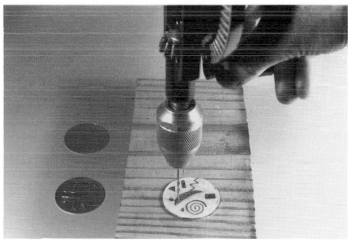

A hole is drilled so that the blade can be inserted for sawing interior shapes.

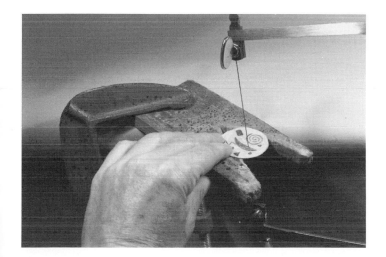

The sawblade is inserted into the drilled hole and the shape is sawed out.

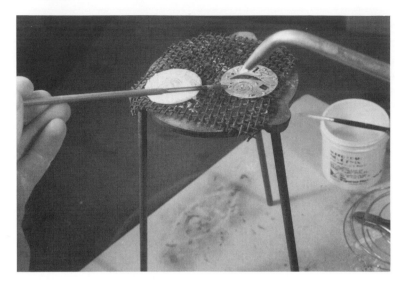

For sweat soldering, solder is first melted on the back of the top layer. The piece is supported on a tripod and screen.

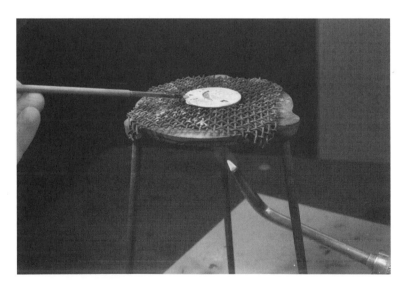

The two pieces are heated mainly from below until the solder flows.

To join the two layers, direct the flame from above and below until the solder flows. A greater amount of heat is usually directed from below, since the bottom sheet is most often the larger of the two and thus requires more heat to reach soldering temperature. When the solder flows, it is sometimes helpful to use tweezers to apply pressure to the top layer to make certain that the two layers are in complete contact.

After pickling and rinsing in running water, file off any excess solder, sand with emery paper, polish and clean.

General Precautions

SAFETY NOTE: Be sure to follow these general precautions when soldering.

- **Use local exhaust ventilation.**
- **Refrain from eating or smoking in the studio.**
- **Wash hands frequently.**
- **Keep a working, class–ABC fire extinguisher in the studio.**
- **Avoid wearing loose clothing.**
- **Keep the workshop neat and clean to avoid accidents.**
- **Avoid the use of asbestos in any form. It is a highly toxic material.**

Bezel Stone Setting

The bezel setting is used for setting a stone with a flat bottom and tapered sides. The bezel, the thin metal band that surrounds the stone's base, is compressed over the taper of the stone to hold it securely in place. Since bezel wire is generally made from a thin, soft metal such as fine silver, it is easily pushed against the stone.

Stones are not the only material that can be set in a bezel. Shells, coins, tiny mirrors, lenses or anything with a flat bottom that can be grabbed by the bezel can be used in this setting.

Pin with wiggle picture that has been bezel set. Other elements have been drilled, wrapped and carved. Roberta Williamson, *Buzz*. Sterling silver.

The stones in this pin are bezel set. Cathleen Bunt. 18K gold, lapis lazuli, red coral and diamonds.

Bezel wire can be left plain or filed with a needle file in a scalloped pattern or some other design. As long as the stone can be grabbed and held firmly in place, any alteration of the basic bezel is workable. Elaborately decorated bezel wire, known as gallery wire, can be purchased from a jewelry supply company.

Tools and Materials

You should have the following tools and materials at hand when setting bezel stones.

- **stone**
- **metal**
- **bezel wire**
- **pencil**
- **bezel shears (or sharp scissors)**
- **needle files**
- **soldering supplies**
- **emery paper**
- **bezel mandrel (optional)**
- **planishing hammer (optional)**
- **stone pusher or rocker**
- **burnisher**

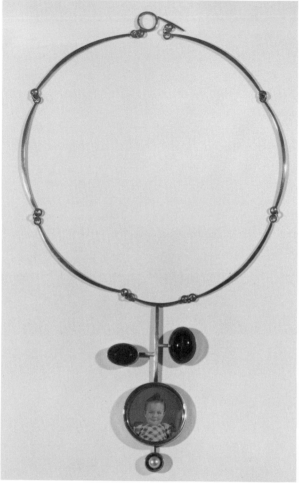

Above: The bezel setting makes a handsome frame for the photograph in this neckpiece. Julian Wolff. Sterling silver, daguerreotype, tiger eye, pearl and ebony.

Opposite: High bezels are used to set the many blown glass elements in this necklace. Mary Ann Scherr, *Penland*. Blown glass and sterling silver.

Left: Pins with bezel set stones. Claire Sanford, *Pins No. 67, 68 and 69*, 1992. Oxidized sterling silver, 22K gold, 7, 7 and 4" (17.8, 17.8 and 10.2 cm).

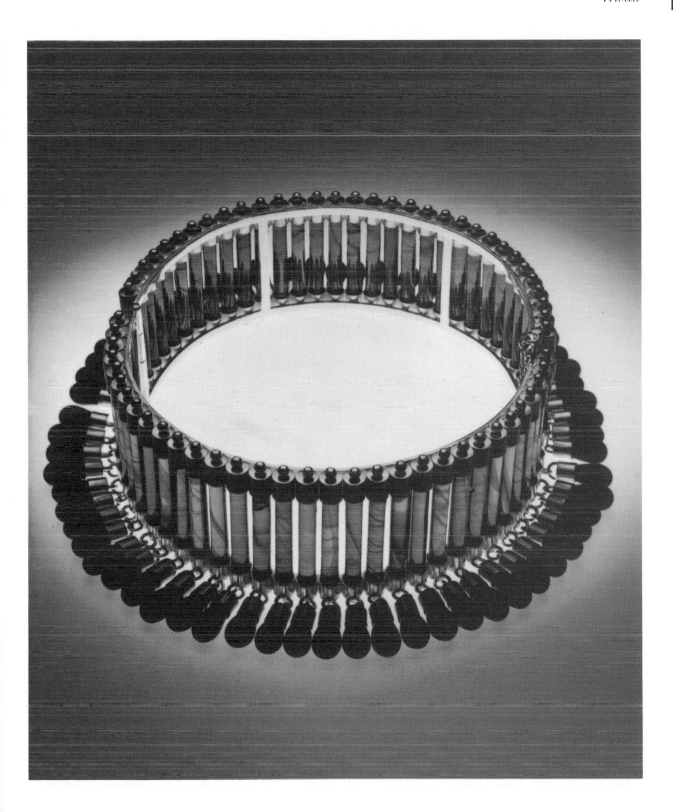

Sizing the Bezel

To determine the correct length of the bezel, wrap the bezel wire around the base of the stone. Mark the correct measurement with a pencil so that the wire can be cut squarely with bezel shears or scissors. An exact fit is crucial for a clean bezel. The ends of the bezel wire should be filed flat until they make perfect contact with one another.

Next, set the stone aside and, with the ends of the bezel wire pressed together under tension, begin the process of soldering. (At this point, the shape of the bezel is inconsequential.) Flux the wire and place a piece of solder directly on the seam. Very little solder is needed to make a good joint. The less solder you use, the better, as long as it fills the seam. Excess solder will make it difficult to set the stone cleanly.

Use a small flame to solder this small piece of metal. It is easy to melt a bezel. If you do, start over again. Pickle the bezel until it is clean. If necessary, file off excess solder and sand the seam smooth with emery paper.

A bezel that is too small can be stretched by tapping it gently with a planishing hammer down the taper of a bezel mandrel until it fits the stone exactly. If a bezel mandrel is not available, the handle of an artist's paintbrush will do in its place. If the bezel is too large, cut out a section and resolder.

Next, flatten the bottom rim of the bezel by rubbing it against a sheet of emery paper that is held or taped flat against the working surface. Sand the bezel to the desired height. The height of the bezel is a functional as well as aesthetic judgment. On a stone with a steep taper, the bezel should be just high enough to catch the stone's taper. On a stone with a side that is nearly vertical, the height of the bezel will depend solely upon how it looks aesthetically.

The bezel wire is measured around the stone and marked with a pencil.

The bezel is soldered closed.

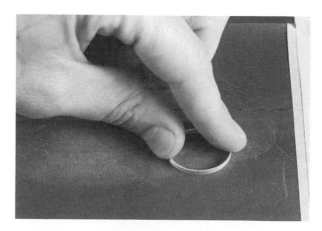

Emery paper is used to sand the bezel flat to the desired height.

Soldering the Bezel to the Base

If the bezel is going to be soldered to a curved surface, such as a ring shank, it must be filed to fit the contour of the base. Do not forget to shape the bezel around the stone before soldering it to its backing.

Working on a tripod and screen set over a soldering surface, such as an annealing pan, place the bezel in position on its backing, and flux the entire piece. Place several small pieces of solder within the bezel around its base. Heat the work mainly from below to avoid a meltdown. As soon as the solder flows around the entire seam, remove the torch and throw the piece into the pickle.

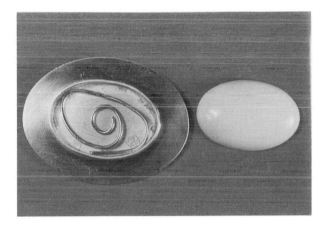

Before setting, the stone may be raised within the bezel cup with a spiraled wire.

The bezel is shaped around the stone and soldered to the backing. Heat is applied mainly from below to prevent the thin wire from melting.

Setting the Stone

The piece must be completely finished before the stone is set. Setting after all other processes, including polishing, are completed will eliminate the possibility of damaging the stone while finishing. A stone can be raised within the bezel with a flat spiral of wire. The thickness of the wire will determine the degree to which it is raised.

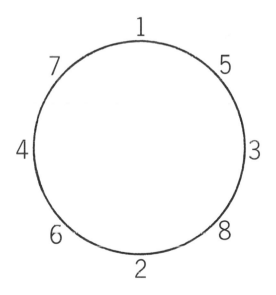

The bezel is pushed over the stone with pressure applied to points in the order indicated in this diagram.

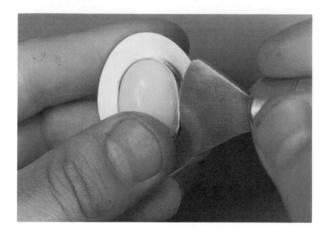

A rocker is used to push the bezel over the stone.

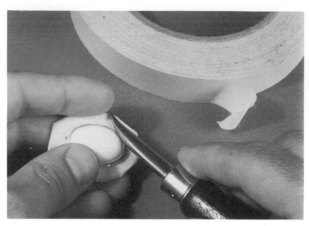

The bezel is smoothed over the stone with a burnisher.

To set the stone, place it squarely in the polished bezel cup. Use a stone pusher or rocker to push points of the bezel against the stone (see page 41). Push first at twelve o'clock, then at six o'clock and then at three and at nine. Next, press between these points until the entire bezel is set against the stone. Alternating sides in this manner will ensure an even distribution of the metal. Use a burnisher to further smooth the bezel against the stone. Be careful not to scratch the metal with the sharp tip of the burnisher. Masking tape may be used to protect the metal while burnishing.

Complete the piece by polishing and cleaning.

Cold Connections

Cold connections are means of attaching materials without using a torch. Cold connections instead rely on mechanical means for joining two or more objects. In the case of materials such as wood, plastic and bone, which cannot be subjected to the high temperatures required in soldering, cold connections are a necessity. By experimenting, you may invent intriguing new applications for joinery that will add strength and interest to your work.

Creative solutions to joinery are sometimes overlooked and the most traditional means are used repeatedly. Both metallic and nonmetallic elements can be attached to metal in a variety of means that may not be immediately obvious but are often the most direct and simplest approach to joinery. Inspiration may come from observing how we connect things in daily life. Stapling, crimping, clamping, sewing, bolting, riveting, interlocking (for example, the pieces of a puzzle) or even the use of magnets, are all possible means for joining materials. Many of these processes are simpler than soldering and require less equipment, yet they can be both functionally and aesthetically effective. Your joint may become the most successful aspect of your piece.

Riveting

A rivet is a cold connection that utilizes a wire inserted through a hole drilled into the materials to be joined. The wire is permanently and securely locked in place when the ends are spread with a hammer. Tubing may be used in place of wire for a rivet that provides a hole through which a chain or some other material can be threaded. Rivets are not only functional but can be used as a design element. Variety in size and color can add pattern and contrast to a work.

To make a rivet, it is most important to create a snug fit by drilling a hole exactly the same size as the diameter of the wire. If the hole is too large, the wire will collapse when hammered. If it is too small, it can be widened with a round needle file. The head of one end of the rivet can be made prior to inserting the wire into the hole. This is accomplished by first filing the wire end flat and then clamping it in a vise, leaving a small length of wire protruding above the jaws. The finer the wire, the smaller the head. If too much wire is left to be fashioned into a head, it will bend rather than spread. Too little wire will not hold the materials together.

Tools and Materials

You will need the following tools and materials at hand when riveting.

- **annealed wire**
- **wire cutters**
- **bench vise**
- **drill**
- **file**
- **riveting hammer**
- **steel surface plate**

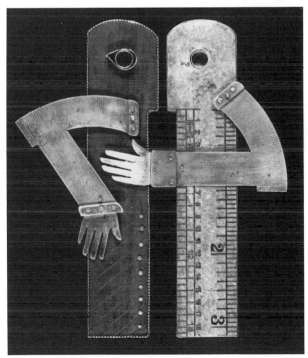

This fabricated piece shows effective use of riveting. Kiff Slemmons, *What's Your Angle?*, 1991. Sterling silver, copper, brass, ebony, ruler, 5 x 4¼ x 3/16" (12.7 x 10.8 x 0.5 cm) Photograph by Rod Slemmons.

All of the enameled rectangles were riveted to this bracelet. Earl Pardon. Enamel, semiprecious stones, sterling silver and gold. Photograph courtesy of the Aaron Faber Gallery.

Types of rivets. (a) Raised head, (b) tube, (c) countersunk and (d) soldered at one end and raised head at the other end.

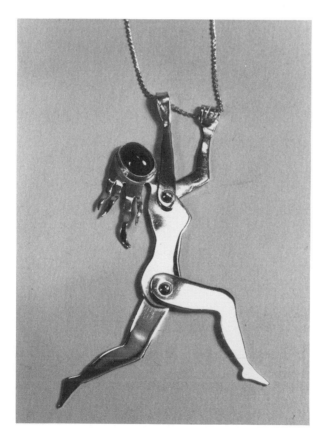

Single rivets are used to attach the swinging limbs on this dancer made by a high school student. Sabine Rouhier.

Use the cross-peen end of the riveting hammer to hit an X in the end of the wire and proceed to spread the head with the flat end of the hammer until it is round and even. Now insert the wire with one completed head into the hole you have drilled in the materials to be joined. The second head is made in the same manner as the first while the rivet is supported against a steel surface plate.

A single rivet will permit the pieces being joined to swivel around the point at which it is riveted. If more than one rivet is used, the materials will be held firmly in place. When using more than one rivet, complete one before drilling the next. This will prevent misalignment of the holes as the rivets are set.

Rivets can be countersunk to make them flush with the surface by using a burr in the drill to cut a depression into which the ends of the rivet can be set. After setting, excess metal protruding above the surface may be filed flush. This kind of rivet is known as an *invisible rivet*.

Another type of rivet is soldered at one end to the base metal. The other end is threaded through a hole drilled in the material to be riveted on. The free end of the wire is spread as described previously. Using this sort of rivet is an effective means of attaching any material through which a hole can be drilled, to a backing of metal.

Nuts and Bolts

Tiny nuts and bolts may be used to fasten two materials together (see *Sources of Supply*, page 156). The bolt is simply threaded through a hole drilled in the materials to be joined. The nut is then screwed on, thus creating a simple and decorative means of joining two materials. Easy removal of the bolts creates the opportunity for interchangeable elements that may be bolted on, moved to a different part of the piece, or removed entirely.

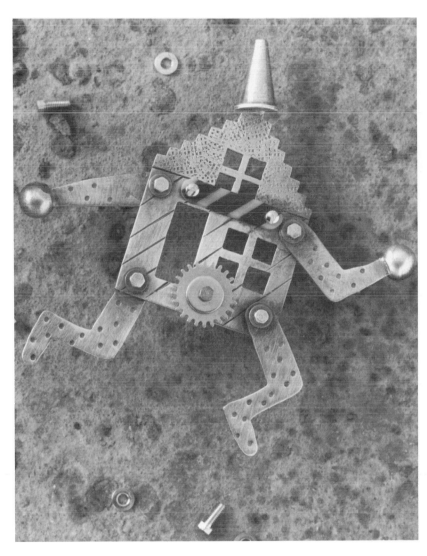

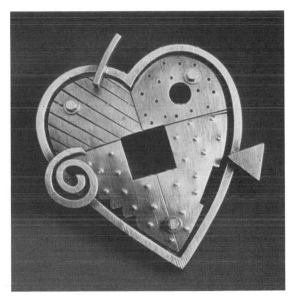

Small nuts and bolts were added to this pin for function as well as design. Thomas Mann, *Outline Heart Pin*, 1991. Sterling silver, brass, copper and bronze. Photograph by Will Crocker.

The limbs on this piece were attached with nuts and bolts that allow them to swing freely. Thomas Mann, *Collaged Running House Pin*, 1992. Nickel, bronze, brass and laminated Lucite. Photograph by Will Crocker.

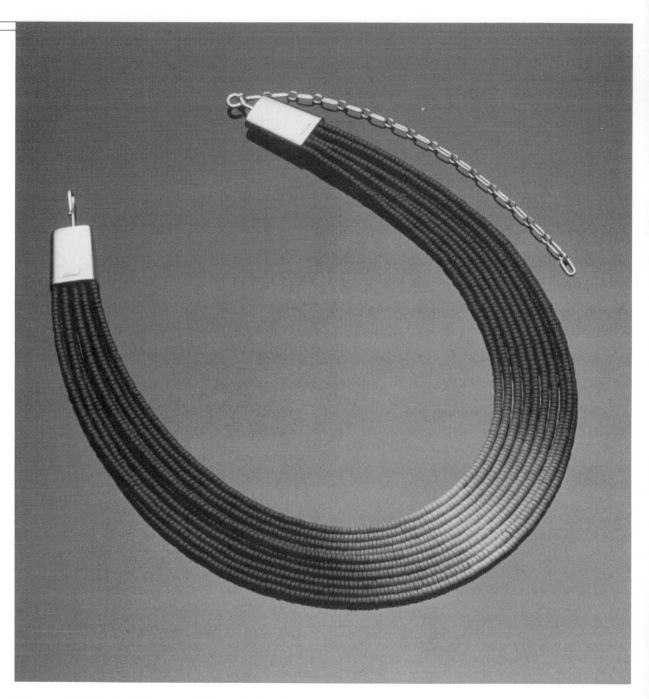

There are 2,500 clay beads in twenty different shades of
black, white and gray on this necklace. Howard Newcomb,
Neckpiece. Porcelain and sterling silver.

Clay 2

The term *clay* has traditionally referred to a material composed of fine particles of minerals that is dug from the earth. This term has been broadened in contemporary use to include other substances whose plasticity resembles that of ceramic clay. In this chapter, we will use the term to include baker's clay, polymer clay and ceramic clay.

Whether you choose to use natural clay or clay that has been created in the kitchen or the chem-

Pattern and rhythm combine to animate these lively fish. Cynthia Chuang. *Fish Pin*. Colored porcelain, glaze, metal and beads, 3 x 1¾" (7.6 x 4.5 cm).

This brooch made from Fimo and metallic powders is an expression of the artist's nomadic life style. Tory Hughes, *Thinking of Home,* 1991.

istry lab, you will find it to be an ideal sculptural material that will respond to your slightest push or squeeze and provide a three-dimensional surface on which to apply design and texture. Thus it is possible to combine—even in a single work—aspects of sculpting in the round, relief, collage, drawing and painting. Although you are working on a small scale, the creative challenge presented by clay is on a par with any of the fine arts.

Baker's Clay

You need not make a special trip to the art supply store to find the materials for creating clay jewelry. Just walk into your kitchen and you will find everything you need to make baker's clay. Safe, inexpensive and as simple as can be, baker's clay allows for unlimited creative expression. When baked, it is as hard as a rock but not as heavy, and it can be painted and coated for permanence.

It is not hard to imagine how the first kitchen clay was discovered. The artistic mind has the ability to find creative uses for everyday processes. Peoples throughout history have made edible, as well as inedible, art with the materials at hand, using them to express themselves as well as create objects of function and beauty. The Ecuadoreans, for example, are known for their intricately detailed, colorful figures and animals made from precolored bread dough.

An Ecuadorean bread dough figure. Many cultures have their unique version of decorative breads. The Ecuadoreans are known for their colorful animals and figures made from precolored dough that has been highly glazed for permanence.

Recipe for Baker's Clay

4 cups (1 liter) flour
1 cup (0.3 liter) salt
1½ cups (0.4 liter) water

Tools and Materials

You will need the following tools and materials at hand when making baker's clay.
- **mixing bowl**
- **measuring cup**
- **plastic bag**
- **garlic press (optional)**
- **toothpick**
- **clay modeling tools (optional)**
- **small knife**
- **waxed paper**
- **kitchen oven or toaster oven**
- **potholders or spatula**
- **cookie sheet, metal baking pan or aluminum foil**
- **coloring agents, such as water-soluble markers, acrylic paints, inks, etc.**
- **small paintbrush**
- **findings**
- **glue**
- **sealer, such as acrylic medium**

Begin by mixing the flour and salt in a bowl. Slowly add water until the mixture is blended and the salt and flour have been moistened sufficiently to work into a ball. Knead the ball on a lightly floured surface, such as formica or waxed paper. Press the dough flat with the heels of your hands and then fold it over upon itself. It is important to knead until the mixture is smooth and consistent

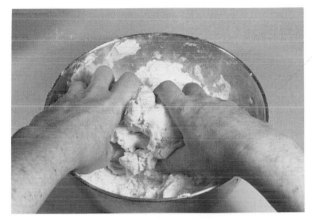

Salt and water are measured and added to the flour.

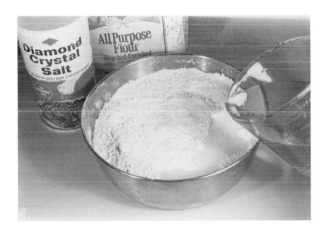

The salt, water and flour are mixed together.

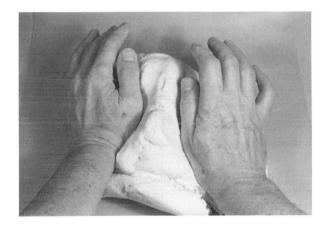

The mixture is kneaded for approximately 10 minutes.

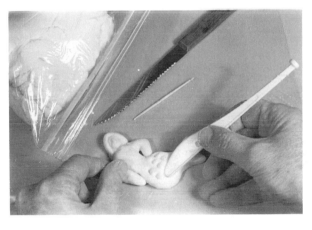

The dough is shaped and textured with the fingers and tools such as a knife, toothpick and a clay tool.

(approximately 10 minutes). If the mixture is too dry, wet your hands and continue kneading. If the mixture is too moist, add a very small amount of flour. The final consistency should not be so dry that it cracks when modeled but not so wet that it is sticky. Dough that is too dry will be difficult to model; wet dough will stick to tools and rise and distort during baking.

Store any unused dough in a tightly sealed plastic bag to prevent it from drying out. Baker's clay can be kept in the refrigerator for up to one week.

Do not use older clay; you will find it difficult to work.

SAFETY NOTE: Baker's clay is inedible, so do not eat it.

Fashioning Jewelry

Break off a small piece of dough and press, roll, slice or squeeze it to create your jewelry. To join dough to dough, dab the pieces with water. Water

A garlic press is used to extrude thin strands of dough that can be used for hair or to add texture.

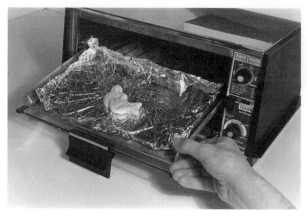

The work is baked in a toaster oven at 350°F.

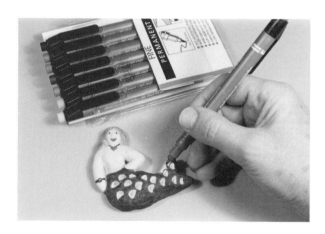

Color is added with permanent markers, ink or acrylic paint.

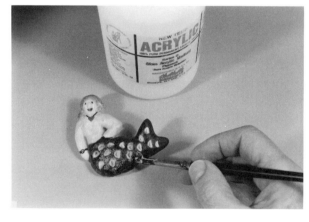

When the color is completely dry, a protective coating of acrylic medium is applied to the surface.

acts like glue; with a little pressure, the pieces will adhere to each other.

You will find that your fingers are your best tools. A toothpick, a knife and clay tools, however, may be handy for delicate work, cutting and instances where a straight edge is needed. A variety of tools and objects may also be used to impress textures into the dough's surface. Squeeze clay in a garlic press to make hair, for example. Thin coils can be rolled and braided to create decorative ele-

ments. Be adventurous. Don't be afraid to try any-thing. If it doesn't work, simply roll up the dough and try again.

Before baking your dough, you may wish to add a piece of thin wire to act as a loop for hang-ing or for decorative purposes. Simply push the wire into the clay, making sure to embed it far enough into the dough that it will hold after the dough is baked.

Baking

Preheat the oven or toaster oven to 350°F (177°C). Place the completed work on a cookie sheet, aluminum foil or in a baking pan and bake it in the oven for approximately one half hour. Baking time will vary, depending on the thickness of the piece and the oven used. Very thin pieces may take as little as ten minutes; thick pieces may take up to an hour. The piece should be hard before it is removed from the oven. **SAFETY NOTE: To avoid burns, use potholders or a spatula to remove the work from the oven.**

Painting the Surface

Once the clay has cooled, it is ready to be embellished with paint, markers or ink. Fine detail can be applied with markers. Permanent markers will not bleed when the final protective coat is applied. Acrylic paints are also excellent for adding detail; they are applied with a fine brush.

Adding Findings

Pin backs, earring clips, barrettes or other findings can be glued to the work with epoxy or any other strong glue. Do not be tempted to handle the piece before the glue has thoroughly dried. Follow the manufacturer's instructions on the label.

Applying a Protective Coat

To seal the surface and protect it from moisture, a sealant should be applied to the dry, decorated piece. There are many excellent non-water-based varnishes and lacquers on the market, but they must be used in a well-ventilated area (such as a spray booth). It is recommended that you use a water-based coating, such as acrylic medium. It is available in matte or high-gloss finish. Use a brush to coat the entire piece except for the finding.

Polymer Clay

When plastics were first introduced, they were primarily used as cheap substitutes for more desirable materials. Today, however, new plastics are being produced and unique ways are being discovered to exploit their inherent qualities for their own sake. Jewelers are discovering that one of these new plastics, polymer clay, offers them much room for exploring and discovering novel techniques.

Polymer clay is well suited for making jewelry. It is relatively light, it is a good medium for detail work and it offers a wide range of techniques that are simple to master. It can be molded, embedded, marbleized, embossed and drilled. And it will accept many surface treatments, including paint, metallic powder and metallic leaf.

Some techniques used when working with polymer clay are similar to those used in other media, such as ceramic clay and glass. Precolored polymer clays can be easily combined to produce detailed effects in the style of caneworked Venetian millefiori glass beads. Other techniques are unique to this medium. With little expense, a few tools and a little practice, a world of possibilities open up to both the novice and the experienced jeweler.

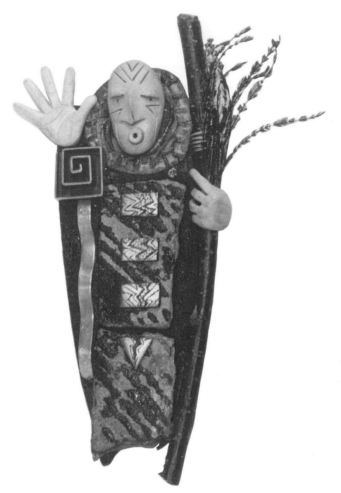

Above: This pin dwells in a wall piece when not being worn. Tory Hughes, *Transformer,* 1992. Fimo, found objects, peacock feather, Mexican silver, old brick and rusted bottle cap. 5" (12.7 cm) high brooch.

Above, right: These surprisingly light rocks are all polymer clay and average about 1½" (3.8 cm) long. Tory Hughes, *Klaymath,* 1989. Fimo, abalone and glass beads.

Several brands of polymer clay are readily available in most hobby and art stores. The most popular brands for jewelry making are Fimo and Sculpey III. These two are similar, yet each has unique qualities that make some jewelers favor one over the other. Although Sculpey is a great deal softer, requiring almost no kneading, Fimo will hold a more distinct edge between adjacent colors. The time and effort necessary to knead Fimo can be somewhat lessened by presoftening the clay. One way to accomplish this is to place it in an airtight plastic bag and immerse it for several minutes in warm water. Because Sculpey III is easier to use, it is ideal for beginners and children. Different brands

of polymer clay can be mixed to exploit the unique qualities of each and to create infinite variations in color.

To achieve permanence, polymer clay is baked in an oven. Because it is not a water-based material, leftover polymer clay will not dry out if left uncovered. Be sure not to expose it to high temperatures or excessive amounts of ultraviolet light, which will render it unusable.

Embedding Materials

Objects such as beads, buttons, gems (genuine or synthetic), crystals, shells, watch parts and coins can be combined and pressed into the soft clay to create intricate designs with great ease. Since polymer clay will not shrink when heated, the clay will not crack when objects are embedded into its surface. As long as the materials can withstand the oven temperature, they are suitable for use. Objects that are in danger of melting can be pressed into the clay and removed before baking. Afterwards, the objects can be glued back in place in the impressions that have been left.

Whenever you combine more than one material, it is important to consider the means by which disparate elements can be integrated to create a unified whole. The repetition of colors, textures and shapes, as well as adherence to a theme,

The various materials used in this pin, with the exception of the eye, were pressed into the polymer clay and fired. To prevent possible melting, the eye was glued in place after firing. By the author. Sculpey III, compass, seed beads, glass jewels and plastic winking eye.

are ways to achieve this end. There is also the challenge of bringing dissimilar objects together. Surrealistic effects can be achieved in this manner.

The process photographs shown here demonstrate how a pin can be made from glass seed beads, bugle beads and a rhinestone.

After kneading the clay to a workable softness, roll it out to a thickness of approximately ¼" (0.6 cm). This can be achieved by flattening a ball of clay with your hands or by using a rolling pin and two dowels ¼" (0.6 cm) thick. Use the dowels as a guide on which the rolling pin will rest when the clay has been rolled to the correct thickness. The outer contour of the clay need not be precut to size since it is difficult to predict the precise shape of the pin until the beads have been applied.

Begin by pressing any large elements (in this case, a rhinestone) in place and working the smaller elements around them. String small beads before applying them, rather than placing each one separately. Beads can be purchased prestrung or you can string them yourself with a thin beading needle and thread. Use tweezers and/or a toothpick to position the beads or to do delicate work that fingers are too large to handle. Small scissors can be used to cut the thread close to the last bead when changing bead colors. You may wish to use several colors and shapes of beads. Choose your colors carefully, keeping in mind compatibility as well as contrast. Press the beads firmly in place and use scissors to cut away any excess clay at the outer edges. When all elements are firmly in place, you are ready to bake your piece.

Baking

Because an oven should not be used for heating food after being used to bake polymer clay, it is advisable to set aside a toaster oven solely for this purpose. Place the work on a piece of aluminum foil and heat it for the time and at the temperature recommended by the manufacturer (approximately 270°F [130°C] for 20 minutes). **SAFETY NOTE: Do not heat polymer clay above the recommended temperature,** for it emits a toxic substance if overheated. Baking time may vary depending upon the brand, color (transparent colors, for example, cure at a lower temperature), the size of the piece and the oven used. It is advisable to test the accuracy of the temperature gauge on your oven with an oven thermometer. When the work is hard and does not respond to pressure, it is finished baking. **SAFETY NOTE: It is important to work in a well-ventilated area.**

Finishing

Glue the finding to the cooled work using a glue made for metal. When the piece is thoroughly dry, use a brush to coat it with acrylic medium or the water-based varnish produced specifically for Fimo by Eberhard Faber. Water-based coatings are safer to use than the more durable but more toxic solvent-based coatings. Do not coat the finding.

Sculpting

The most direct method for working in polymer clay is to simply sculpt recognizable or abstract forms with your fingers and, where helpful, small tools. A toothpick—that simple but ever-so-useful tool—is excellent for defining intricate shapes.

Emphasize changes in forms—where one shape ends and another begins—by using different colors of clay and defining crisp edges. This method of working lends itself to relief sculpture in which two or more layers of clay are built up to create depth. Do not hesitate to add small pieces for detail.

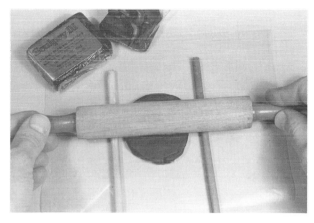

A rolling pin is used to flatten the clay. Two ¼" (0.6 cm) dowels are used as a guide to control the thickness of the clay.

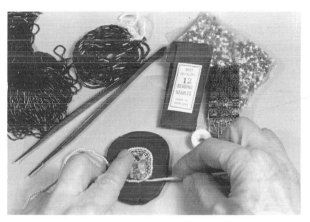

A rhinestone and prestrung beads are pressed into the clay.

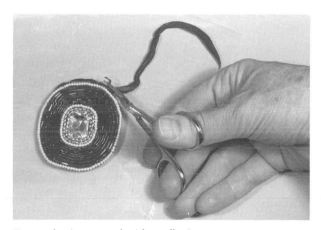

Excess clay is removed with small scissors.

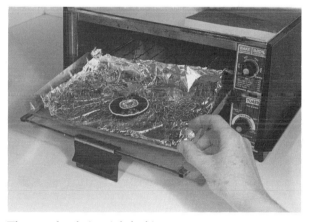

The completed piece is baked in a toaster oven.

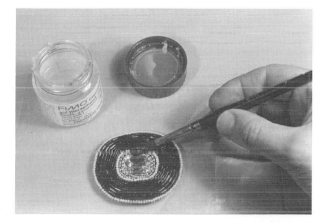

After the finding is glued in place, a protective coating is brushed onto the surface.

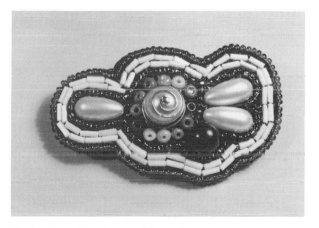

Pin by the author. Sculpey III, beads.

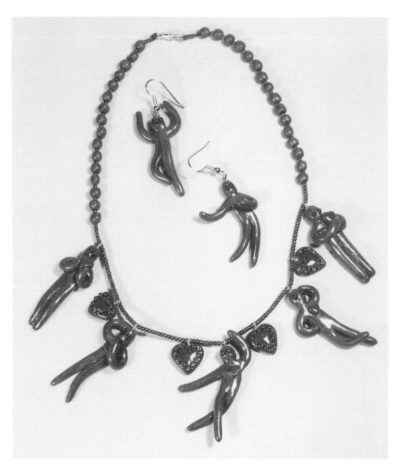

This necklace, created by a high school student, was sculpted in Fimo. Seed beads were pressed into the hearts before the piece was baked in a toaster oven. Theresa Hung, *Dancing Sweet Hearts*.

In this pin, the motif on the postage stamp is developed in the polymer clay. Notice the three-dimensional elements of this tiny relief sculpture. Tory Hughes, *Robot GB*, Fimo and postage stamp.

Stamped Impressions

Stamping is a gratifyingly simple means of creating surface design in polymer clay. You can use stamps to mass produce everything from pins for organizations to an item for your own line of jewelry.

Impressions can be made by pressing a textured object or a raised design, such as a rubber stamp, into the surface of the soft clay. Do not hesitate to experiment with anything you find. Scout around and collect a bag of "found tools." You can even make your own stamps by carving different designs into each side of a soap eraser with an X-Acto

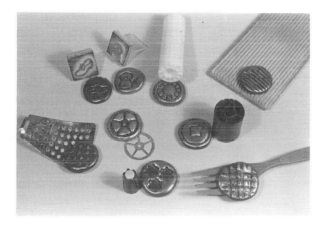

Impressions were pressed into the polymer clay with several objects found around the house, including a ribbed wooden paddle, a plastic fork, a marker top, a watch gear and a section from a metal vegetable strainer.

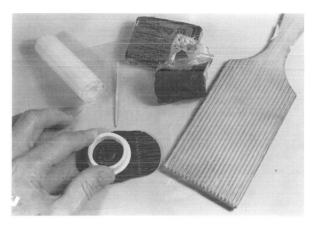

Textures and patterns are stamped into a piece of flattened Sculpey.

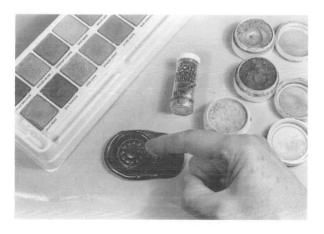

Metallic powder or eye shadow is applied to the surface.

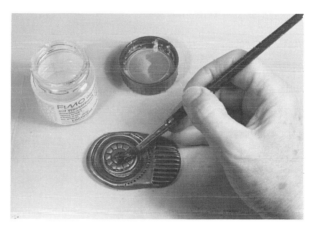

After firing, a protective coating is applied with a brush.

knife. Experiment with trial impressions in a scrap piece of clay. When you have chosen the stamping tools you wish to use, make your impressions carefully, paying special attention to the placement of each stamped image.

When you have completed composing and stamping, add color to your work by using your finger to apply metallic powder or powdered eye shadow to the surface of the piece. Several colors can be blended together or a single color can be applied. The color will not reach the recessed portion of the clay, which will remain black (or whatever color the clay is); the surface will be coated with a shimmering glaze of color. The contrast between the original clay color and the bright, new colors heighten the visual impact of the design.

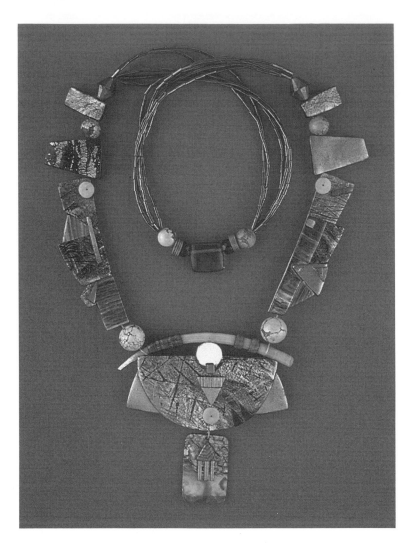

Metallic leaf was used on some of the surfaces of this piece to echo the lustered surfaces of the other materials. Tory Hughes, *Lunae,* 1990. Fimo, various painted, metallicized and textured surfaces, mirrors, dentalium shell and turquoise.

Metallic Leaf

Metallic leaf is available in many art supply stores in several different metals, both precious and non-precious. Imitation gold and silver leaf are inexpensive and particularly striking, especially when used in conjunction with black polymer clay. Metallic leaf comes in sheets so thin that the slightest air current will send it flying. It will also stick to your fingers and tear easily. To avoid these problems, cut the leaf with a pair of scissors between the sheets of tissue sold with it. Then carefully lay the leaf on your clay piece and burnish it with your finger to make it adhere smoothly and completely.

An interesting effect may be achieved by using a small rolling pin or dowel to roll out the leafed clay. As the clay is stretched, the metallic skin will break apart in a distinctive, crackled pattern. The clay may then be shaped by folding, pinching or cutting, and finished in the manner described previously.

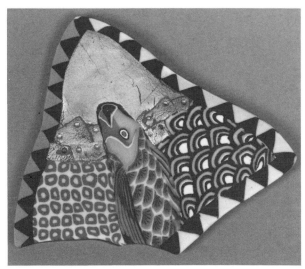

Kathleen Amt, *Fish*. Polymer clay millefiori and gold leaf.

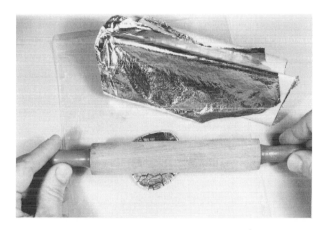

A rolling pin is used to flatten and spread the metallic leaf. The result is a characteristic crackled effect.

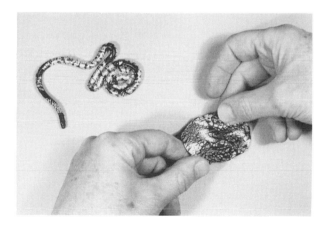

The piece is then pinched, folded or otherwise molded into the desired shape.

Canework and Decorative Surface Designs

Sometimes traditional techniques in one medium can be translated to another, providing us with possibilities we might not otherwise have considered. This is the case with canework. Originally a method used in making Venetian millefiori glass beads, it has been mimicked in polymer clay to create beads and other forms of jewelry.

Canework consists of rods (or canes) of a colored design that runs the full length of the rod. When the cane is cut at any point, the cross section will reveal the design. When working in polymer clay, you may wish to slice a thin section of the design to be appliquéd onto another piece of clay, or a longer section which, when pierced, will create a bead.

An exciting characteristic of polymer clay canework is its ability to be rolled thinner and still retain detail. Thus, you can create a short, fat cane

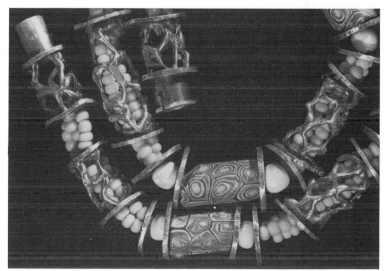

The glass beads in the center of this necklace were made using the millefiori technique, which is often mimicked in polymer clay. Ramona Solberg. Cast, millefiori, pony and trade beads.

As you can see from these earrings, shaded, intricate patterns can be achieved when skilled hands master canework. Steven Ford and David Forlando. Caned polymer clay.

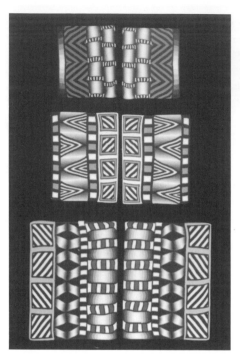

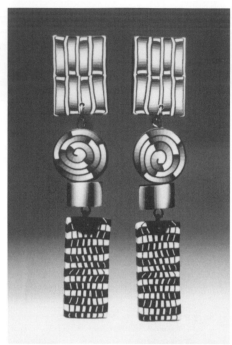

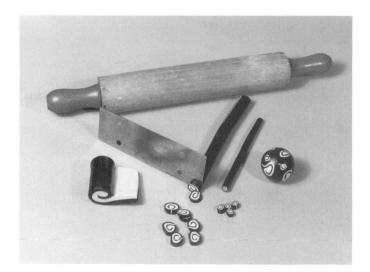

Jelly roll cane rolled thinner, sliced with a wallpaper stripper blade and flattened into a ball of clay to create a decorated bead.

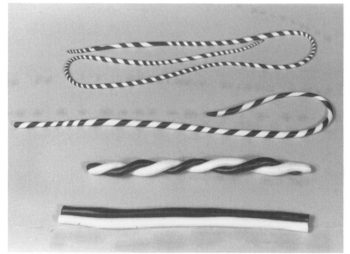

Two coils twisted together and rolled very thin.

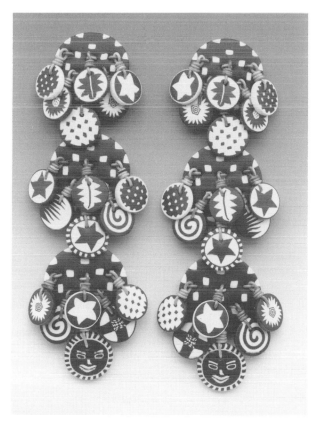

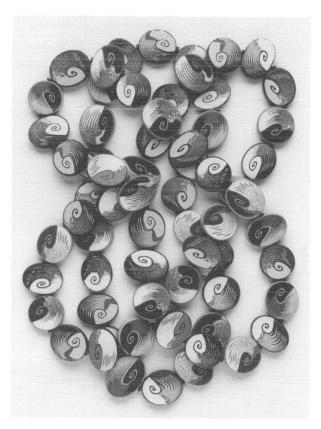

Pier Voulkos, *Triple Black-and-White Harry Earrings*, 1992. Polymer clay, 4¼" (10.8 cm) long. Photograph by George Post.

Pier Voulkos, *Three Black-and-White Swirl Neckpieces*, 1992. Polymer clay, 13" (33 cm) long. Photograph by George Post.

and then roll it thin to produce a long cane of the same design but smaller in diameter. Canes of twisted colors and canes of striped colors may be combined to create new, more intricate canes. Highly complex canes may contain scenes, animals and figures. Once you get the hang of the process, there is no limit to the variety of patterns and designs that you can make.

Fimo is recommended for canework because of its ability to maintain a clean edge when two or more colors are combined. Simple designs should be made before more complex ones are attempted. You may choose to begin by making two colored coils of clay, twisting them together and then

Two colored coils of clay are twisted together and then wrapped around a thicker coil of a third color. This combination of clay is then rolled back and forth to smooth its surface and make it uniform. It is then ready for slicing into bead size—or it can be rolled thinner and applied as surface decoration to clay of another color.

wrapping them around a thicker coil of a third color. Coils are made by rolling the clay back and forth under your open hands. Waxed paper, a pane of glass or sheet of hard plastic are good surfaces on which to work. When all three coils have been combined, roll them back and forth a few times to smooth them together. Continue rolling if you wish to make the new combination coil thinner.

A simple canework design can be created by laying several coils of different colors together lengthwise and then wrapping a sheet of clay around them. (The sheet of clay is made by flattening clay with a small rolling pin or dowel.) The sheet can be cut to the desired shape with a single-edged razor blade or a wallpaper stripper blade; these are available in most hardware stores. It is important to use a thin blade for cutting polymer clay, as a thick blade may distort delicate work.

To pierce a hole for stringing, use a toothpick, a thick sewing needle or a thin knitting needle, depending on the desired size of the hole. Be certain that the hole is made cleanly and is large enough for the cord, wire or thread that you plan to use for stringing.

Next, try making a striped cane pattern from sheets of alternating colors that are piled one upon another. Make a number of blocks of striped pat-terns, using several colors and different thicknesses of stripes for variety. If you have the patience, try working in great detail, cutting very thin sheets to make the stripes.

A checkerboard pattern can be made from a block of stripes. To do this, slice the block at equal intervals perpendicular to the stripes. Next, reverse and reposition each line of stripes so that it is shifted one stripe over (that is, white next to black), thus creating a checkerboard pattern.

In addition to canework, beads may be decorated by simply adding elements onto a coil, ball or other shapes made from solid-colored clay. The simplest dots, stripes or x's may be pressed into the clay surface by rolling the bead around until the design is fully integrated into the surface.

You can fashion beads of any shape, including round, tubular, oval, rectangular, arched or free-form. The bead's hole need not be positioned in the most obvious place: in its center. It may be pierced anywhere, as long as the bead hangs gracefully when it is strung.

Bake the beads on a wire suspended in the oven. Be careful that they do not touch any surface; such contact could cause them to distort. The high-sided tray that comes with most toaster ovens is fine for this purpose. The ends of the wires can rest on the tray's sides.

Several clay coils of different colors are laid together length-wise and then wrapped around the outside with a sheet of clay. The resulting combination coil (known as a cane) can be rolled thinner to the desired thickness. The longer you roll the cane, the thinner it will become (without losing detail).

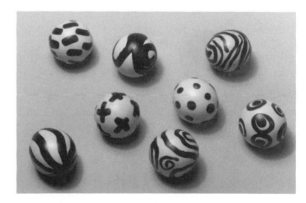

Decorative elements of a contrasting color are added to the surface of the beads and rolled around until they blend into the background.

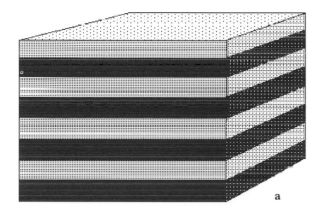

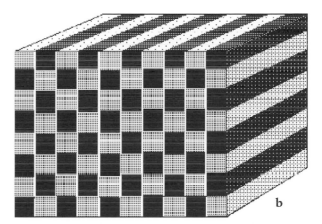

A checkerboard pattern is made by (a) stacking a pile of clay sheets of two alternating colors. (These sheets are made by rolling the clay flat with a rolling pin or dowel.) This striped pile is then sliced as you would slice a loaf of bread. The slices are flipped over and repositioned so that the squares alternate colors (b).

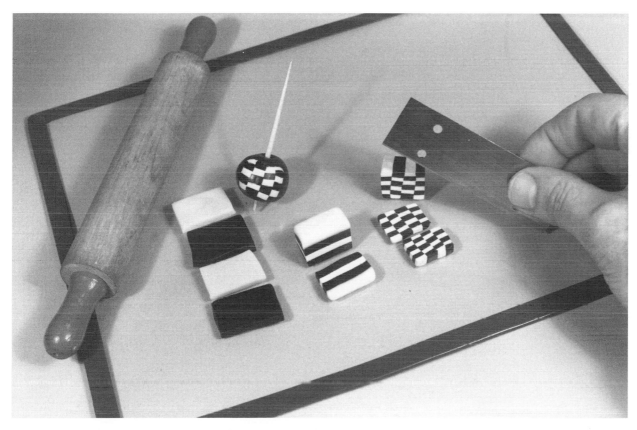

The checkerboard loaf is made from sheets of two different colors which are piled, sliced and then repositioned and sliced again. This patterned slice was applied to a round ball of clay and rolled around until it became smooth. A toothpick was used to pierce a hole to create a bead.

Ceramic Clay

Ceramic clay jewelry has a rich historical tradition that encompasses many techniques and styles. Your imagination may be stimulated by a collar of clay beads retrieved from an ancient Egyptian tomb, some hand-painted Peruvian ceramic beads or a contemporary neckpiece. The material itself is inspirational: clay can be easily sculpted and its earthy texture and color gives it an inherently natural feel.

Choker-length neckpiece. Howard Newcomb. Porcelain beads in nine different shades, sterling silver clasp and spacer beads. *(See Color Section)*

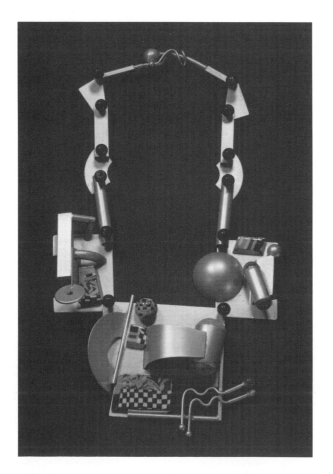

Slabs of patterned colored clay were set in metal to create this exquisitely designed neckpiece. Cynthia Chuang. Airbrushed brass, porcelain, semiprecious beads, 20" (50.8 cm) long. *(See Color Section)*

Peruvian hand-painted clay beads.

These clay beads were all handmade and strung together on cord. The color in faience is mixed into the clay rather than being applied to its surface. Egyptian collar. Faience. XVIII Dynasty. From Thebes. The Metropolitan Museum of Art. Bequest of Howard Carter, 1939. (49.105.1)

Clay is readily available at most general art or ceramic supply companies. The small quantities needed for jewelry making can be obtained at a negligible cost. It comes in several colors, including red, brown, white and buff. Clay that has been precolored with oxides is available in the whole spectrum of colors (see *Sources of Supply*, page 156). These colored clays may be combined to create a design that requires no glazing and retains its natural matte surface. To achieve permanence, clay is fired in a kiln.

Tools and Materials

You will need the following tools and materials for your ceramic clay projects.

- **ceramic clay (in one or more colors)**
- **needle tool**
- **toothpick**
- **index card or a wire clay cutter**
- **Play Doh extruder**
- **small rolling pin, a printer's brayer or a dowel**
- **newspaper**
- **steel wool**
- **kiln**
- **findings**
- **glue**

Extruded Beads

Clay that has been forced through a shaped hole emerges as a long coil whose wall conforms to the hole's shape. The extruder manufactured by Play Doh for use as a children's toy happens to be the perfect size for making beads. It can be purchased at a toy store. Tiny beads may be extruded using a clay gun available at most ceramic supply houses. The clay used in these extruders must be soft enough to be easily squeezed yet firm enough to hold its shape. Thus, it is important to knead water

into the clay if it is too hard or, if the clay is too soft, to allow it to dry out in the open air.

The coils that emerge from the extruder may be sliced into bead length by cutting perpendicular to the coil with the edge of an index card, an X-Acto knife or a thin wire. To complete the bead, use a needle tool or toothpick to pierce a hole. Make the hole wide enough to allow for shrinkage that takes place in the drying and firing processes. The degree of shrinkage will vary, depending on the particular clay.

Firing

When the beads are thoroughly dry, they are fired for permanence in a kiln. Kilns are available in many sizes. An electric glaze test kiln is an excellent size for firing ceramic jewelry. If you do not own a kiln, check with local schools that offer ceramics classes—they may be willing to fire clay jewelry free or for a nominal fee. Unglazed beads may be piled together to fit easily into an unused corner of a kiln.

It is important that the clay be thoroughly air dried before it is fired. Humidity will have an effect on the rate at which the clay dries. Clay that is cold to the touch is still too wet to fire. Even when the clay appears dry and ready, safeguard against any remaining moisture by placing it in a kiln set on low temperature for a minimum of one hour. The beads can then be fired to the temperature recommended by the clay's manufacturer.

The ideal maturing temperature of a specific clay body is represented by a cone number (see *Appendix*, page 152). The firing temperature must be reached slowly over several hours. If your kiln is equipped with a pyrometer, its temperature can be read from the gauge. Kilns without pyrometers must be fired using pyrometric cones that are set inside the kiln where they can be seen through the peephole in the kiln door while the kiln is firing. Each pyrometric cones is designed to melt at a spe-

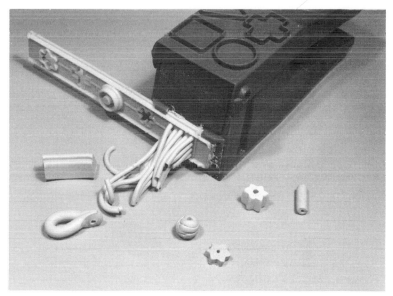

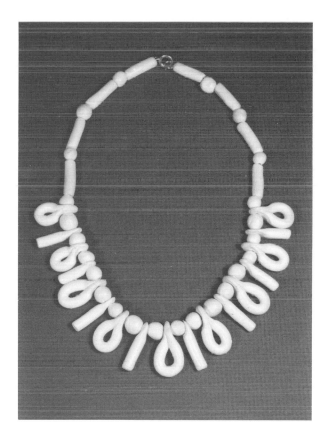

The clay beads used in this choker were extruded on a children's Play Doh machine. By the author.

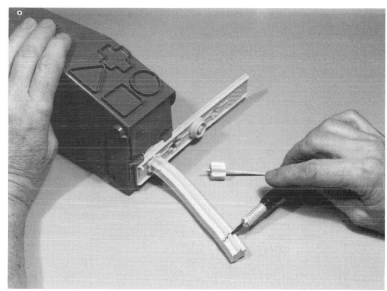

The clay is extruded through the Play Doh machine and cut with an X-Acto knife. A stringing hole is pierced with a toothpick.

cific temperature. One or two warning cones, that melt at progressively higher temperatures, may be placed next to the final cone, that melts when the desired firing temperature is reached. When this final cone melts, it is time to turn off the kiln.

The rate at which the temperature climbs in the kiln will vary with the size of the kiln—the larger the kiln, the longer it will take to reach a given temperature. Clay that is damp or fired too quickly will explode. Allow fired clay pieces to cool slowly. Remove them from the kiln only when they are cool enough to handle with your bare hands. **SAFETY NOTE: The kiln must be properly vented.**

Colored Clays

Colored clays are available in a variety of hues, including pinks, blues, violets, greens and yellows. A colored clay sample kit is an excellent means for beginners to get acquainted with this medium (see *Sources of Supply*, page 156). Single-colored clay may be used or several colors may be combined.

Marbleized clay can be created by kneading two colored clays together. Stop kneading when you have achieved the desired marbleized pattern. If you overknead, the two colors will blend to create a third color. Another way to create a mulitcolor effect is to add colored clay to a clay base of a contrasting color. For example, if you make a round ball from one color clay and add small decorative shapes of differently colored clays to its surface, you can integrate the colors by rolling the ball around until the surface is smooth. Colored clays can also be pressed into a flat sheet of a base color by using a small rolling pin, a printer's brayer or a dowel. When the clay is dry, surface blemishes may be removed with steel wool.

A miniature hand extruder can be purchased from a ceramic supplier. This tool comes with discs for extruding different shapes. Extruded clay can be used for hair or a textured effect, or inlayed into a background of a contrasting color.

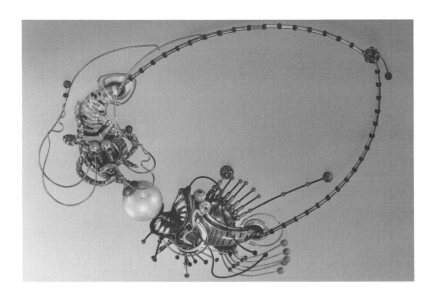

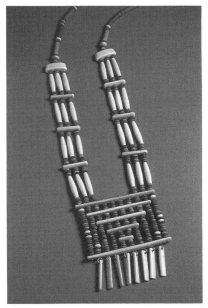

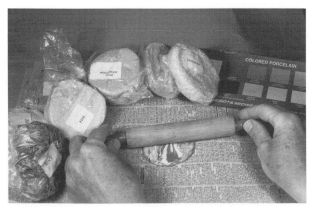

Above Right: Necklace. Ina Chapler. Colored clay beads, bone mah-jongg counters and bone beads. Photograph by James R. Gilmour.

Above Left: The artist has let her imagination go wild in this jewel of a deep-sea encounter. Cynthia Chuang, *Squid and Fish Neckpiece*. Porcelain, metal and semiprecious beads, center: 7" long x 3" wide. (17.8 cm long x 7.6 cm wide).

Left: Two colored clays may be kneaded together until they become marbleized.

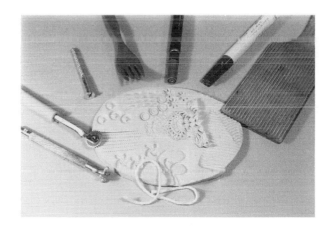

Many objects found in the home and workshop can be used to impart texture to clay. Here string, a leather tool, a tracing wheel, a screw, a plastic fork, two marker caps, lace and a ribbed wooden paddle were used to make patterns in the clay.

A miniature clay extruder will produce coils of many shapes that can be added to clay of a contrasting color for design or texture.

Making Impressions in Clay

Textured and patterned ceramic beads, pins, necklaces and buttons can be fashioned using colored clays. Clay can be rolled into a ball between the palms of your hands to create a round or oblong form. It may also be flattened with a small rolling pin or dowel into a sheet and cut to shape with a needle tool. Use your fingers to sculpt clay into virtually any shape. If you are using several colored clays, it is a good idea to work on newspaper that can be changed frequently so that the colors do not pollute one another.

A sewing wheel, zipper, butter paddle, pastry tip, seed pod, shell, gear, fancy button, leather stamp, screw head or just about anything you can lay your hands on will make an interesting impression in clay. Carefully press the implement into the clay. If the clay contains the proper amount of moisture, it will not crack and a well-defined impression will be transferred to the clay.

Finishing

To finish your clay piece, fire it as described previously. Glue on findings, using any glue made for ceramics and metal. Although it is not necessary to seal the unglazed, fired clay, some people choose to

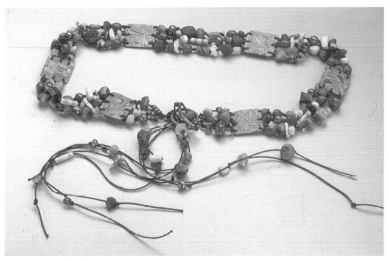

Necklace made from beads of various materials collected in the artists' travels. Jim Brunelle and Charles Webb. Handmade clay beads. Photograph by Michael Sundra.

coat its surface with an acrylic spray or with wax. **SAFETY NOTE: Use adequate ventilation when using spray acrylic. Always use spray in a spray booth or out of doors.**

String beads on nylon fishing line, a leather thong, linen thread or any strong material. One way to design the placement of the beads is to lay them out in a box of sand that will prevent them from rolling around. Should uncoated beads become soiled after wearing, they may be washed in a dishwasher.

Paper is available in many forms including the paper string,
called Mizuhiki, from which this necklace was constructed.
Hiroko and Gene Pijanowski, *Oh! I Am Precious No. 8.*
Mizuhiki and plexiglass, 27 x 17 x ½" (68.6 x 43.2 x 1.3 cm).

\mathcal{P}aper 3

\mathcal{P}aper is a material of such great abundance, familiarity and versatility that it is seldom treated with the respect that it deserves. We eat off of paper plates, read newspapers, cover our walls with wallpaper and make purchases with paper currency. Something made from paper is rarely beyond our reach.

Since the invention of paper in second-century China, untold creative uses have been discovered for this amazing medium. For the artist, paper provides a surface on which materials such as paint, ink, pastels, colored pencils and collage can be applied. Paper can be shaped into three-dimensional forms by folding, bending, gluing or scoring. Paper can be surprisingly strong and durable—even waterproof.

Paper is particularly suited for jewelry making. It is light, inexpensive (if not free) and available in a wide variety of forms. In addition, the techniques for working in paper are "low-tech" and simple to master. You may become inspired by the material itself. Look around and you will find paper in the form of sheet, rope, board; paper that has been handmade, cast or laminated; metallic paper, patterned paper and embossed or textured paper.

With the emergence of the ecology movement, recycling has taken on new dimensions. The artist can capitalize on this by using paper with a previ-

Drawings on handmade paper. Claire Jeanine Satin, *Kandinsky Neckplate #1.*

ous life as a springboard for a creation. Interesting sources of free paper include newspapers, posters, magazines, catalogs, discarded wallpaper books, greeting cards, photographs and paint chips. Computers, copiers and fax machines generate predecorated paper in enormous quantities.

There is little you cannot do with paper. Don't pass over this remarkable medium because it is so accessible and easy to use. Take advantage of all that it has to offer.

 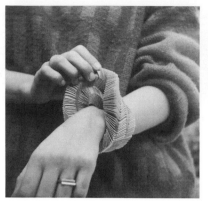 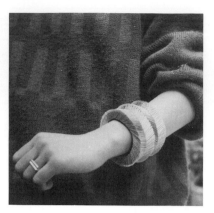

Paper bracelets made from folded paper strips joined by elastic. This ingenious use of paper in a bracelet demonstrates how flexible it can be when used innovatively. Nel Linssen, 1986, 1987.

Rolling Paper

The materials needed to make rolled paper beads can be found in almost any home or classroom. Although the process is basic, the results can be satisfying and as varied as the paper from which they are made. The beauty of the finished product derives from the subtlety exercised in selecting the paper, in the color combinations that are chosen, and in mixing the paper beads with other beads chosen for their compatibility of medium, pattern and color. Search for interesting beads at flea markets, garage sales or in your own jewelry box.

Rolling Paper Beads

When selecting paper for this process, experiment by trying a variety of papers; a design printed on paper may look very different after it has been rolled. Try cutting the page both horizontally and vertically to produce different effects. For large beads, you may want to use thicker paper.

Tools and Materials

You will need the following materials at hand for rolling paper.

- **colorful paper (from magazines, wallpaper, etc.)**
- **scissors or paper cutter**
- **white glue**
- **toothpicks**
- **clear acrylic finish**
- **a variety of handmade or purchased beads (optional)**
- **strong thread or dental floss**
- **needle (optional)**

Each bead is made from an elongated triangle with a base of approximately 1" (2.5 cm) and length of approximately 8" (20.3 cm). Cut the triangles with scissors or a paper cutter. If you are using thin

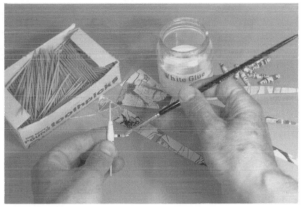

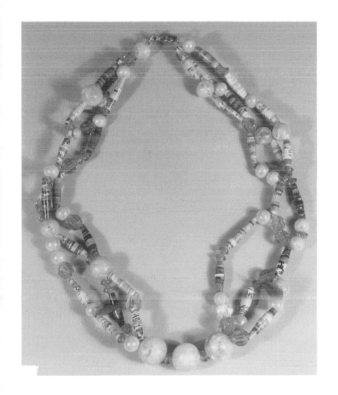

Left: A necklace made from rolled paper beads combined with beads found at flea markets and garage sales. Joelle Hochman.

Above: A paper triangle is rolled around a toothpick and fastened at the end with white glue.

paper, you may be able to cut through several sheets at one time. To enlarge or reduce the width of the bead, widen or narrow the base of the triangle. Lengthen the triangle to make the bead thicker. It is wise to try several widths and lengths until you achieve the size you desire.

Each bead is rolled around a toothpick. Begin by holding the base of the triangle against the toothpick and rolling it up tightly and evenly until you reach the tip of the triangle, which should be centered on the bead. Use a second toothpick to apply white glue under the tip of the triangle and then finish rolling. Hold the glued tip down until it is dry. Carefully slide the completed bead off the toothpick.

A protective coating of clear acrylic may be applied to paper beads to make them more durable and waterproof. First string and hang the beads horizontally, taking care that they do not touch

one another; this will prevent them from sticking together when they are coated with clear acrylic. Following the manufacturer's directions, apply several light coats of spray acrylic rather than a single heavy coat. **SAFETY NOTE: Use adequate ventilation. Do all spraying in a spray booth or out of doors.** Clear acrylic finish is also available in liquid form and can be applied with a small brush.

When thoroughly dry, restring the beads. You can use the paper beads alone or in combination with beads made from other materials. Strong linen thread, dental floss or any thread that is difficult to break may be used for stringing. You may need a needle to string beads with small holes.

Try stringing beads of different designs in an irregular order or in a pattern. It is also wise to consider contrasting colors and sizes. To avoid having to string the beads several times before arriving at a pleasing strand, line up the beads in a box of dry sand. The sand will prevent the beads from rolling around while you experiment with different combinations.

Rolled paper beads combined with a variety of commercial beads made from glass and metal.

Mat Board

You can create jewelry that is both strong and lightweight with mat board. You can also add dimension to mat board by scoring and then bending it. Discarded scraps of mat board can often be obtained from a local framer or school art department. Full sheets can be purchased at an art supply store; a single sheet of mat board goes a long way. Smooth black board provides a particularly receptive surface for colored pencils.

Cutting

Begin experimenting by cutting several shapes from the mat board using scissors or a paper cutter. You may wish to cut freehand, or you can draw your shape in pencil prior to cutting. Fine sandpaper may be used to make minor adjustments in the form and to smooth any rough edges. If you need to replicate a particular shape for earrings or a modular piece, cut a template from stiff paper, such as oak tag. This template can be traced as many times as necessary. Remember to flip the template in

order to reverse the direction of an asymmetrical shape when making the second of a pair of earrings.

To create a relief effect, smaller shapes may be glued onto the original shape with white glue.

Tools and Materials

You will need the following materials for your mat board projects.

- **black mat board with a smooth finish**
- **sharp scissors or a paper cutter**
- **X-Acto knife**
- **fine sandpaper**
- **lead pencil**
- **Berol Prismacolor colored pencils (or a brand of similar quality)**
- **colored markers (optional)**
- **white glue**
- **toothpicks**
- **clear acrylic finish**
- **findings**

Above: Detail of photograph.

Right: Made from spiral overlapping modules, this necklace is flexible and its size can be easily adjusted. Nel Linssen, 1989. Plastic-covered paper.

Scoring

By scoring and bending, you can introduce a third dimension into this technique. It is necessary to score the mat board before bending to produce a crisp line at the bend. Score in straight lines rather than curves and cut from one edge to the other. To score, use an X-Acto knife to cut partially through the board. Be careful not to cut all the way through. **SAFETY NOTE: Keep your free hand behind the cutting tool to avoid injury.** The mat board should bend easily along the scored line. To make a *mountain bend,* score on the top side of the board. To make a *valley bend,* score on the under side of the board.

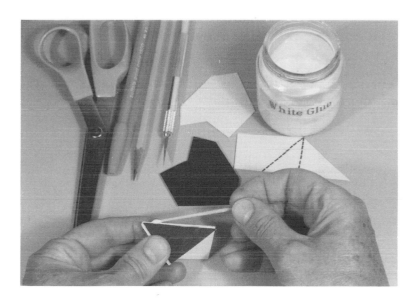

The mat board is cut out, scored and glued with white glue to create a three-dimensional shape.

Gluing Scored Mat Board

To hold the work permanently in the desired three-dimensional shape, the board must be glued to itself or to another piece of mat board. Use a toothpick to apply the white glue. Hold the glued boards together for several minutes until they stick together on their own.

You may need to cut a separate mat board shape that can be glued on to close a form or to serve as a base for a three-dimensional form. In order to cut the correct size, place the bent form on top of a piece of mat board and trace the desired shape with a pencil. Cut out the shape and glue it in place.

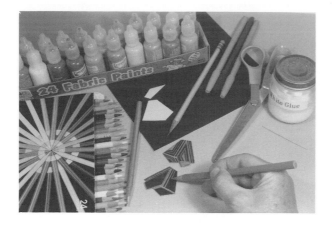

Color is added with colored pencils, markers and fabric paints.

A layer of clear acrylic spray is applied to protect the surface.

Applying the Decoration

After the glue is dry, you are ready to draw your design on the black surfaces with colored pencils. Berol Prismacolor is one brand of quality pencils that offers brilliant, intense colors. In addition, they are waterproof and lightfast. Metallic colored pencils are effective when used with basic colors.

Finishing

When the piece is thoroughly dry, spray it with acrylic gloss. Follow the manufacturer's instructions on the can. **SAFETY NOTE: Use adequate ventilation. Spray in a spray booth or out of doors.** To complete the piece, attach any necessary findings with white glue.

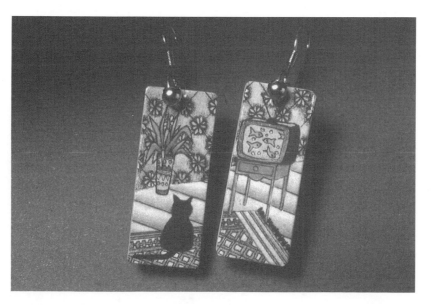

Hand-colored lithographs printed on rag paper, mounted on mat board and varnished. Daryl V. Storrs, *Earrings in 18 Colors*.

Collage

The word "collage" derives from the french word meaning "to glue." You may be familiar with the collages of the noted artists Schwitters, Braque and Picasso. In collage, dissimilar elements made from paper and other materials are glued together to create a single coherent image. This technique is easily adapted to jewelry making. The scale is small, but the concept can be wide-ranging. Finding materials for your collage offers the excitement of a treasure hunt. Once you are aware of the possibilities of this technique, bits and pieces once overlooked will become fascinating, valued finds.

Right: This collage of rag papers that have been painted with acrylic paint and 22K gold leaf has been assembled in a manner similar to the Seminole Indian strip quilting technique. Susan Naylor, *Paper Pins.* Photograph by Pam Monfort.

Tools and Materials

You will need the following materials for collage projects.

- **collage materials, such as stamps, cards, small parts of discarded toys and games, magazines, tiny transfer letters, maps, labels, stickers, expired credit cards (which often include holograms), junk mail, newspaper and so forth**
- **sharp scissors**
- **mat board**
- **tweezers (optional)**
- **white glue**
- **small brush**
- **findings**
- **clear acrylic finish**

Suggested materials for collage include postcards, wrapping paper, maps, marbleized paper, paint chips, origami paper, stamps and playing cards.

Collaged pin made by the author from a stamp, a photograph, wrapping paper, a postcard, a metallic star and small washers. The three-dimensional frame was made from paper straws that were covered with wrapping paper and cut in half the long way.

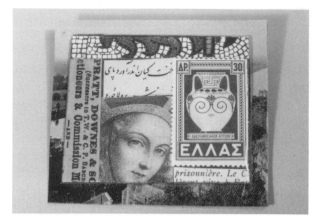

Collaged pin made by the author from sections of a stamp, postcards, a calendar, wrapping paper and a magazine illustration, mounted on mat board and coated with clear acrylic spray.

Hand-tinted photograph mounted on brass and sealed with varnish. Glenn Bering, *Cow Pin*.

Making the Collage

Begin by cutting out the images to be combined in your collage. Craftsmanship is important, so take the time to cut precisely.

You may wish to limit your palette and choose images that relate to a single theme. This will help to unify your work. It is sometimes helpful to begin with one or two large elements and then add smaller details. Three-dimensional elements may be added to create a low relief. Tweezers are handy for placing delicate pieces.

Spend as much time as needed to arrange the collage until you are satisfied with it. When the composition is set, use a small brush to glue each piece to the mat board backing.

Finishing

After the glue has dried, complete your collage by coating it back and front with acrylic medium or clear acrylic spray finish. **SAFETY NOTE: Use adequate ventilation when spraying. Spray in a spray booth or out of doors**. Next, use white glue to attach findings such as pin backs, tie tacks and earring backs.

Slide Mount Collage Pins

A small collage framed in a slide mount can make for an intriguing, unique pin.

Slide mounts can be purchased at a photo supply store. They are the ideal ready-made frame for a collage. The Gepe slide mounts are manufactured in two sections designed to be snapped together, each with a glass window mounted in a plastic frame. To use a slide mount for your collage, modify the directions given under *Collage* on page 77 by gluing the collage elements onto a thinner backing, such as a rectangle cut from an index card. Cut the rectangle to fit into the slide mount; make it slightly larger than the glass window. To secure the collage within the mount, simply snap the two sections of the mount together with the collage sandwiched between them.

One way to decorate the plastic frame surrounding your collage is to use a small square of sponge to stipple acrylic paint on it. Experiment with loading the sponge with paint and dabbing it onto paper before applying paint to the frame. Use two values of a single color; apply the dark value first. Wash the sponge and allow the first coat to dry before stippling on the lighter value. Experiment to discover other methods to decorate the frame.

Complete your work by gluing on a pin back.

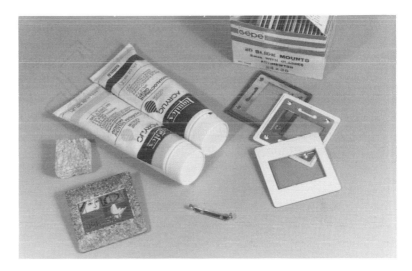

To make a slide mount pin, simply snap your collage into the Gepe mount, decorate the plastic frame and glue on your pin back.

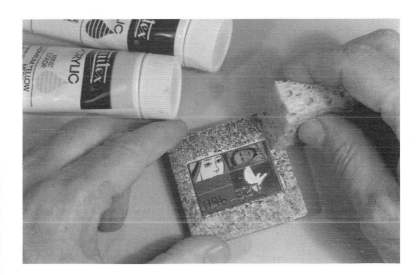

This stippled surface treatment was applied with a small section of sponge that had been dipped in acrylic paint. Two values of the same color were used to create this effect.

Additional Materials

In addition to most of the materials needed for collage jewelry (see Tools and Materials, *page 77) you will need the following:*

- **Gepe slide mounts**
- **index card**
- **scissors**
- **acrylic paint**
- **1" (2.5 cm) square section of sponge**

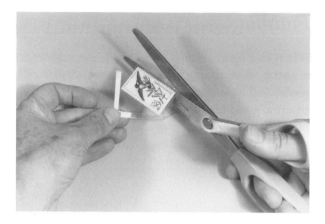

Use a scissors to remove excess film, leaving a ¹⁄₁₆" (0.2 cm) border of laminating film surrounding the image.

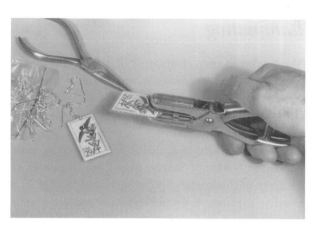

Punch a hole and add findings to make earrings.

Above: Collar. Gijs Bakker, *Adam,* 1988. 18K gold–plated brass and a laminated photograph.

Left: Laminated pin and tie tack by the author. The images used here were cut from a magazine.

Origami

Origami, the Japanese art of paper folding, is as basic an art form as one can find. (The word "origami" actually means "paper folding" in Japanese.) In origami, sculptural shapes are created from paper simply by folding—no cutting or gluing is involved. Working with small pieces of paper, you can make delicate, intricate shapes that can be made into jewelry. Fold a single form to create a tie tack or pin, or replicate a construction many times to make a necklace or pair of earrings.

Tools and Materials

You will need the following tools and materials for your origami projects.

- **origami paper**
- **clear acrylic finish**
- **findings**

Many origami cranes were strung together to create this necklace.

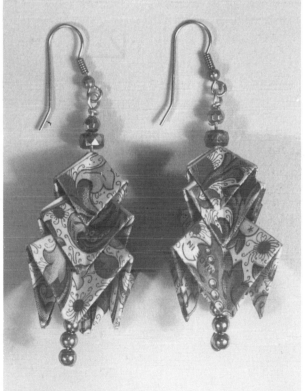

Earrings made by the author from simple origami forms. The paper forms were strung on wire, and glass and metal beads were added.

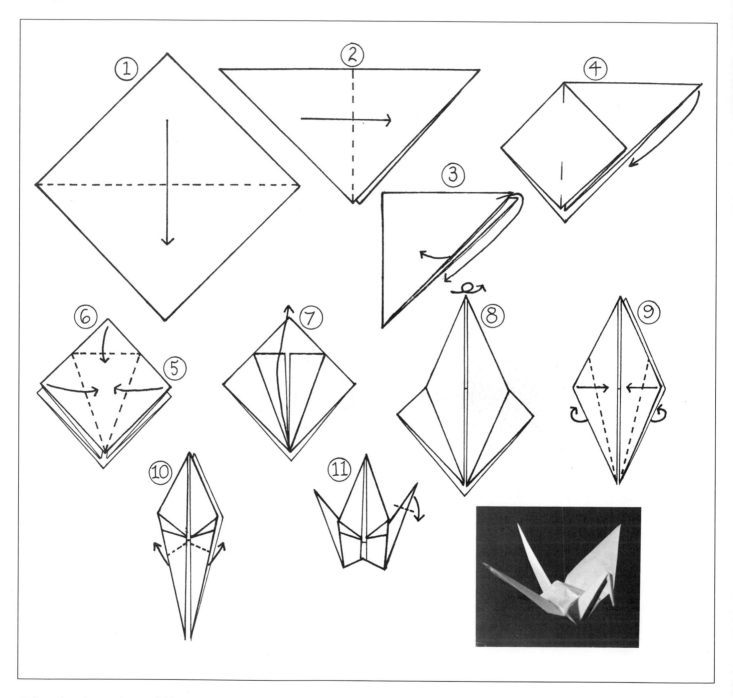

Follow these instructions to fold an origami crane. There are many books available that show how to make hundreds of other origami forms.

Folding

Although you can purchase beautiful colored and patterned papers specifically designed for origami at an art supply store, any paper that does not rip when folded and that will hold a sharp crease without cracking can be used. The paper should also be thin enough so that it does not become excessively bulky after several foldings. Magazine, wrapping and typing papers are excellent for this purpose. Origami is traditionally made from square pieces of paper. Folds should be accurate and crisp. Rub each crease with your thumbnail to make as sharp an edge as possible.

The diagram illustrates how a single origami form, the crane, can be used to make jewelry. (Books on origami are readily available that offer many additional forms.) The crane is perhaps the most popular traditional origami form. It has come to represent peace ever since a young girl, a victim of the atomic bomb that was dropped on Hiroshima in 1945, folded one thousand cranes with the help of many people as a plea for an end to war.

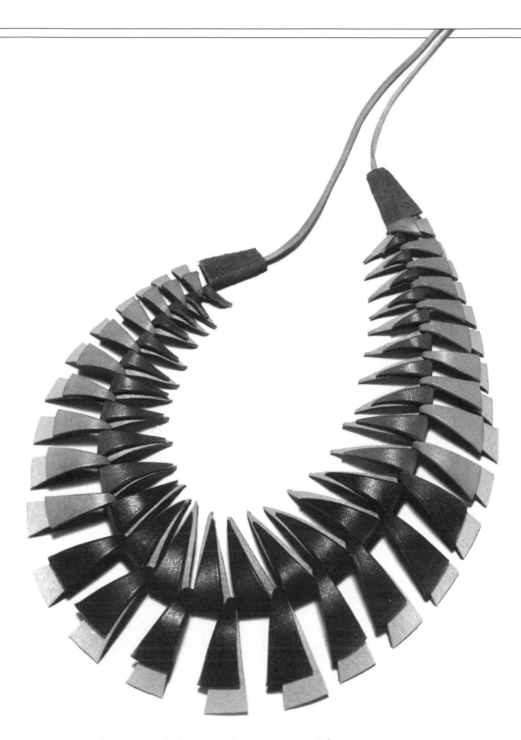

Necklace made from a single, tapered strip of $3^{1}/_{2}$ ounce
(99 grams) cowhide that was cut, wet and formed. Daphne
Lingwood, *Pinetree*.

\mathcal{L}eather 4

\mathcal{T}raditionally a material used for making clothing and accessories, leather is beautifully suited for jewelry making. Strong yet flexible, it can easily be transformed into jewelry by twisting, stretching, bending and compressing. Its natural earthy coloring and smooth, absorbent surface provide a rich and accepting background for the addition of color. Used for adornment since Neolithic times, leather continues to appeal to the craftsperson. Its versatility as a material allows for contemporary applications of traditional techniques as well as its use in combination with new techniques and new materials.

Leather is an inexpensive material, and a little of it will go a long way. Scraps of leather can often be obtained for the asking from leather craftspeople, who often discard small pieces perfectly suited for jewelry making. The vegetable-tanned leather required for tooling, stamping, printing press impressions and wet forming can be purchased at a leather supply company (see *Sources of Supply*, page 156). If you are not using the leather for such purposes, any type will do.

Leather is available in many textures, colors and weights. Its thickness is usually measured in ounces. One-ounce leather, for example, is $\frac{1}{64}"$ (.04 cm) thick, while eight-ounce leather is $\frac{1}{8}"$ (0.3 cm) thick.

Duck feather earrings. Paul Burnett. Tooled, wet-formed and painted leather.

Working with Vegetable-Tanned Leather

Tools and Materials

You will need the following tools at hand when working with vegetable-tanned leather.

- **vegetable-tanned leather**
- **oak tag**
- **pencil**
- **X-Acto knife or sharp scissors**
- **pointed leather modeling tool**
- **swivel knife**
- **metal-edged ruler**
- **mallet**
- **stamping tools (commercial or studio made)**
- **sponge and water**
- **electric hair dryer**
- **contact cement**
- **rotary leather punch**
- **additional punches (optional)**
- **acrylic paint, markers, inks, etc.**
- **small paintbrush (size 1 or smaller)**
- **leather finish**
- **findings**

Tooling

Tooling is a method for impressing designs into vegetable-tanned leather. Vegetable-tanned leather is used for this technique because it will respond to the pressure of a tool when wet and it will retain an impression when dry. For tooling, the leather must be thick enough to hold a deep impression. Five-ounce leather is a good thickness for creating tooled jewelry. By moistening the leather and either drawing designs on it with a pointed model-ing tool or stamping impressions on it with metal stamping tools, you can decorate the surface of the leather with lines, shapes or patterns.

To begin, make a pattern from stiff paper, such as oak tag. Trace the pattern onto the rough side of the leather with a pencil. If you are making non-symmetrical earrings, be certain to reverse the direction of the second earring by turning the pattern over before tracing, so that one earring is the mirror image of the other. Cut the leather to shape using sharp scissors or an X-Acto knife.

SAFETY NOTE: When using an X-Acto knife, keep the hand that holds the leather behind the cutting tool to avoid injury.

Dampen both sides of the leather evenly using a sponge or spray bottle, beginning with the flesh side (the rough side) and following with the grain side (the smooth side). You should sponge the entire piece initially to avoid leaving water stains in certain areas. Thereafter, smaller areas may be remoistened as they begin to dry out. The leather will darken when it is moistened. Be careful not to saturate the surface; leather that is too wet will not hold an impression.

After the leather is properly moistened, place it on a smooth, hard surface with the grain side up. Use a pointed modeling tool (or a small knitting needle) to make thin lines in the surface of the leather. Hold the tool in the palm of your hand and press it firmly against the surface. Use a ruler with a metal edge to guide the tool to make straight lines. Curved lines may be drawn freehand or against a template cut from cardboard. You may wish to go over a line several times to deepen the impression.

Facing Page: Pattern for collar necklace to be traced by placing on a folded sheet of tracing paper (as shown) and cut from thick paper, such as oak tag.

↑Place on fold↑
of paper

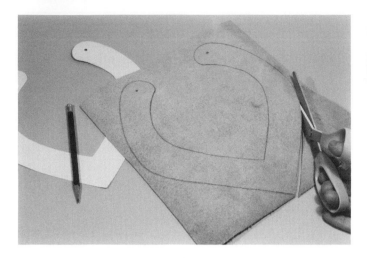

The pattern is traced onto the rough side of the leather with a pencil and cut out of the leather with an X-Acto knife or sharp scissors.

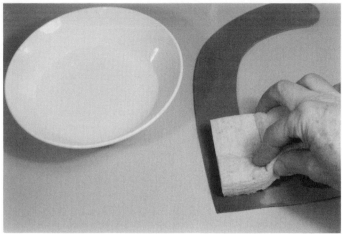

The leather is dampened with a moist sponge to prepare it for tooling.

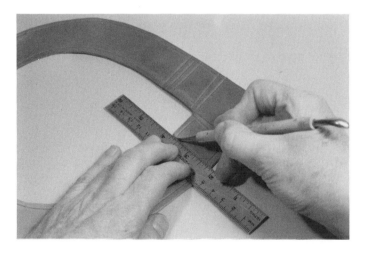

A modeling tool is pressed into the moist leather to impress a line into its surface.

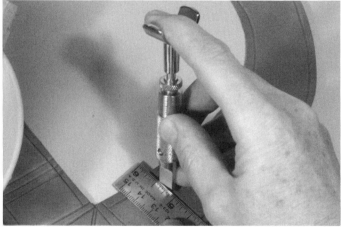

A swivel knife may also be used to make marks in leather if you wish to create sharp, crisp lines. Note that the knife is tilted at a slight angle away from the body as it is pulled toward the user.

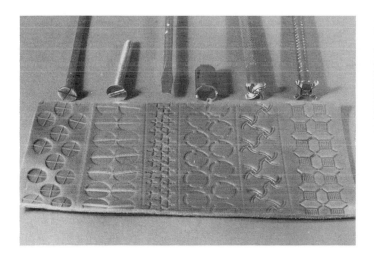

Homemade, found and commercial tools may be used to impress designs into the moistened leather.

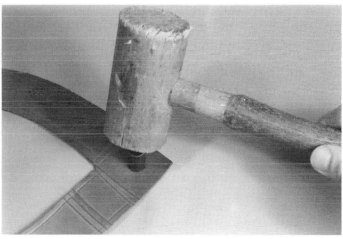

Stamp an impression of a section of metal tubing into the leather by hitting it with a mallet.

A swivel knife is used to create sharp, incised lines. This knife actually cuts partially into the leather rather than just compressing its surface. The barrel of this tool is held between the thumb and middle finger, with the index finger pressing down on the yoke. The little finger rests against the blade and acts as a guide as you swivel the knife along the leather to cut straight or curved lines. The knife is tilted back away from the body at a slight angle. Draw the knife towards you. Do not cut more than halfway through the leather, or you will weaken the piece. Practice is essential to mastering this tool.

Stamping

In addition to drawing lines in vegetable-tanned leather, designs can be impressed in its surface with decorative stamps. Almost any metal tool can be used to mark leather. A large assortment of commercial decorative metal-stamping tools can be purchased from a leather supplier (see *Sources of Supply*, page 156). Stamps can also be made from any object that will leave an interesting impression and will withstand the blow of the mallet. A nail point or head, a screwdriver or screw head—these are just a few of the found stamps that can be used. You can also fashion your own custom stamp by filing one end of a brass or copper rod.

To leave an impression of a stamp in moist leather, place the leather on a hard, smooth surface, hold the stamping tool perpendicular to the leather and strike its head with a mallet. Experiment on a piece of scrap to get accustomed to the tools and to try different combinations of stamps. The more you experiment with your tools, the more likely you are to discover unique and exciting uses for them. You may wish to stamp a design repeatedly to create a pattern. Interesting effects may also result from overlapping stamped images.

The pressure of a printing press has impressed lace, screening, a leather thong, paper clips, a linoleum cut and scraps of the leather itself into the moistened leather.

Printing Press Impressions

By rolling materials through a printing press or rolling mill along with a sheet of leather, you can transfer designs onto leather with great ease. Any materials are suitable, provided that they are thin enough (no thicker than a standard paper clip) that they will not damage the rollers or cut through the leather. Experiment on scrap leather with different materials such as lace, string, carved linoleum or metal mesh. Determining the degree of pressure necessary to create the desired impression may take several experimental passes through the press.

To print impressions, you must use dampened, vegetable-tanned leather. Place the material from which you wish to make an impression on top of the leather and roll it through the press as if you were printing a woodcut. If you use metal objects or any hard material that could damage the roller, protect the press with a sheet of soft metal, such as copper or brass. A well-defined image should emerge from the press.

Wet Forming

To impart dimension and form to your work, leather can be wet formed. By wet forming, we truly take the art of creating leather jewelry into the realm of small sculpture. Only vegetable-tanned leather can be wet formed, because it is easily manipulated when damp and will hold its shape after it dries. It can also be stretched, twisted, bent, molded or draped over an object. When dry, it will permanently conform to its new shape.

When working on a small scale, vegetable-tanned kipskin is a good weight of leather to use. After soaking the leather in warm water until it is limp, shape it with your hands. Clothespins or paper clips can be used to hold the formed leather in place until it dries, a process that can be hastened with the aid of an electric hair dryer.

Exciting forms can be achieved by first slitting the leather with an X-Acto knife and then twisting it into itself through the resulting slits. These slits may also be used as decorative elements by rolling

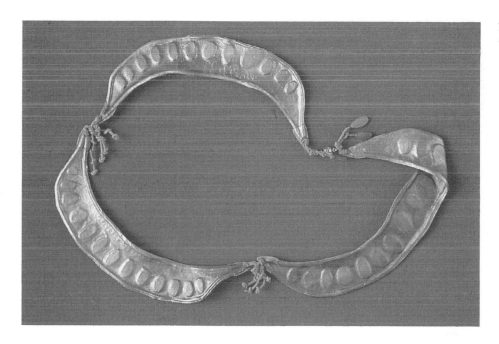

Kris Eberhard, Pod Necklace. Wet-formed, vegetable-tanned leather, acrylic paint.

Right: Cowhide pin colored with dye and acrylic paint. Daphne Lingwood, *Mask Pin*. Made from a single piece of 3½-ounce cowhide.

Below: Rex Lingwood, *Pin*. Vegetable-tanned leather.

The vegetable-tanned leather is wetted and formed to the desired shape.

A hair dryer is used to speed up the drying process. When the leather is completely dry, it will hold its form.

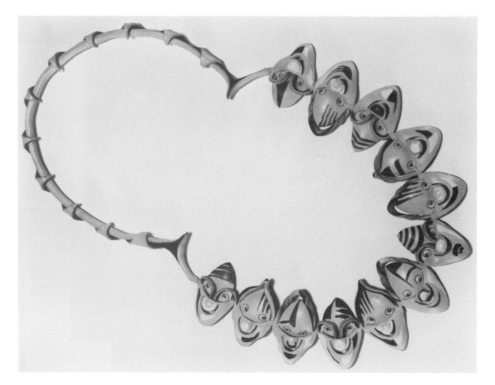

This leather necklace was punched, wet-formed and painted with acrylic paint. Daphne Lingwood. Cut from one oblong piece of leather.

Fringed leather may be twisted or braided.

A slit cut into leather can be curled back for a unique effect.

Slit or punched openings in the leather may be bent to create different effects.

the two edges back, away from the slit. Wet leather can be stretched to create ruffles on an edge, or you can fringe edges by making parallel cuts with a knife or scissors. The fringe can be left plain, twisted, curled or braided.

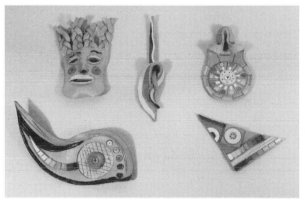

Experiments with wet-formed and tooled leather. Color was added with acrylic paint.

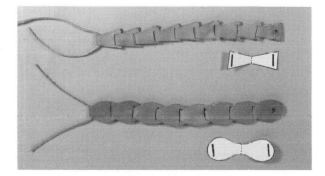

A slit module can be inserted into an identical module and combined with other modules to create a leather chain.

Finishing

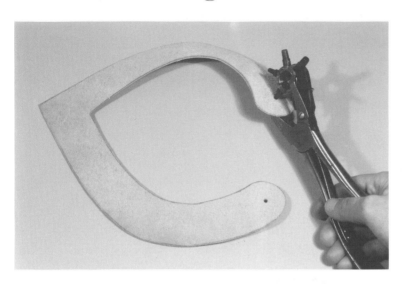

A rotary punch is used to punch a hole of the desired size into the leather.

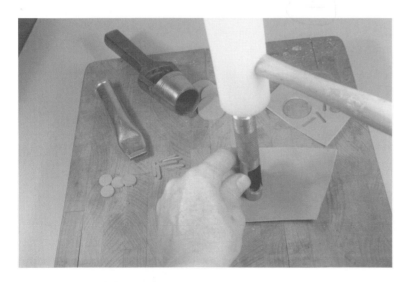

Drive punches of different shapes are hit with a mallet to cut out the corresponding shapes. Either the positive shapes or the negative holes may be used.

Hole Punching

Holes of varying sizes can be punched in leather with a rotary leather punch. Holes are added for decorative purposes or to accept findings, a leather thong, a chain or a wire hook for hanging. It is advisable to mark where you would like the center of a hole to be placed with a pencil before punching. To punch a hole, rotate the punch wheel until you find the desired hole size and then squeeze its handle.

Drive punches are single-holed punches that are available in several different shapes and sizes. They are driven into leather with a mallet. Support your work on a tree stump or block of end-grain wood so as not to damage the punch. Punch single or multiple holes for functional or decorative purposes. These holes can themselves be used as single design elements or glued onto a leather background. Punches can be driven partially into leather to compress shapes in its surface.

Gluing

Joining leather to leather is as simple as gluing paper. A contact cement, such as rubber cement, is the adhesive of choice for leather. Rubber cement is waterproof and flexible, even when dry. The cement is applied to both surfaces and allowed to dry until it becomes tacky to the touch. At this point, the pieces to be joined are pressed together. Be certain to align them accurately, for once they touch they cannot be moved. When joining leather to the smooth side of another piece of leather, it is helpful to roughen the smooth surface with sandpaper. This will allow the cement to grab more effectively. **SAFETY NOTE: Work in a well-ventilated area. Keep the cap on the container when not in use.**

Adding Color

With leather as your canvas, you can create a miniature painting with almost any painting medium. Leather's smooth, absorbent surface will accept dyes, paints, markers, shoe polish and inks. Acrylic paints are particularly suited for painting leather jewelry, for they adhere well to the surface, can be applied in great detail with a small brush and can be mixed in subtle colors. If the paint is too thick and application seems difficult, it can be thinned with a small amount of water.

Preserving Leather

Time and wear are known to improve the look of leather, but you may wish to protect its surface. Applying wax, clear liquid acrylic or spray acrylic to the decorated leather will preserve and waterproof it as well as impart a lovely sheen to its surface. **SAFE-TY NOTE: Use adequate ventilation when using spray acrylic. Always spray in a**

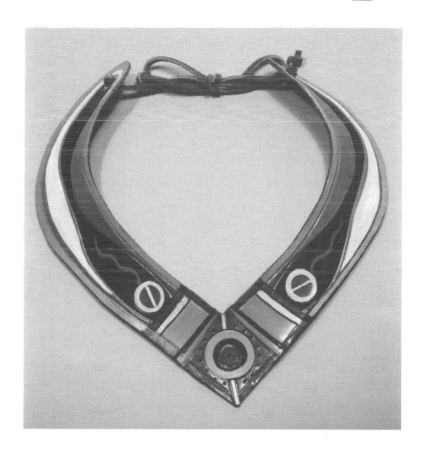

Left: Color is added with a small brush and acrylic paint.

Above: The completed collar with a leather thong knotted in place.

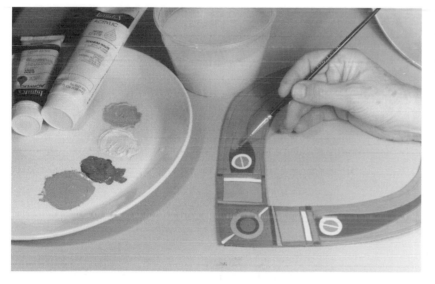

West African leather bracelets. A leather thong was used to
finish off the edge of the top bracelet. Shells were sewn on
with heavy-duty thread.

spray booth or out of doors. Liquid and paste waxes manufactured specifically for leather are available, but waxes designed for other purposes, such as Simoniz (old formula) car wax, will also work quite effectively.

Fasteners and Findings

Inexpensive kits can be purchased that make the setting of snaps and rivets in leather an easy procedure. These kits are simple to use and include instructions. A snap is one type of closing mechanism for a bracelet or necklace. A rivet is used to permanently attach leather to leather. The use of Velcro, or a leather thong tied through punched holes are other ideas for fastening leather.

Findings—such as pin backs, ear clips, tie clips, barrettes or bolo backs—may be added with any glue designed for use with metal. Attach ear wires by threading them through a small, punched hole.

A thong may be cut with sharp scissors from the edge of a sheet of leather.

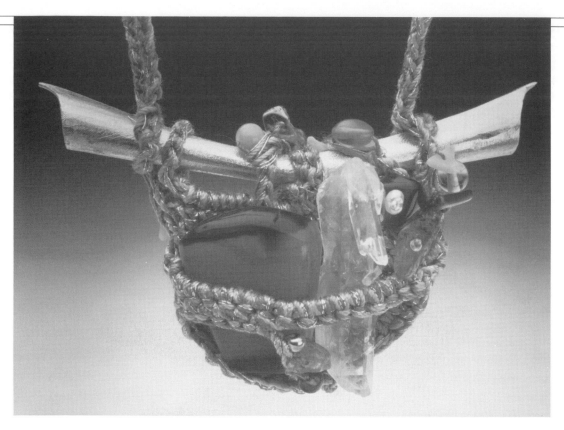

Risa Benson, *Silver Spiculum Pendant*. Sterling silver, carnelian and rock crystal joined with crocheted silk yarn.

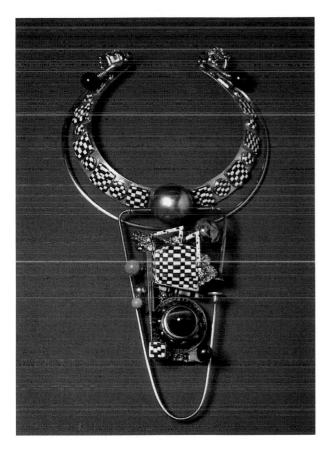

Neckpiece. Cynthia Chuang. Colored ceramic clay (porcelain), airbrush sprayed brass, glaze, semiprecious stones and beads.

Tory Hughes, *Shrimp Pin*. Fimo and found materials.

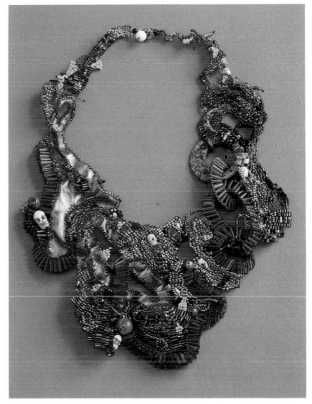

Necklace. Joyce Scott, *Other Side*. Glass seed and bugle beads and mixed media.

Twined, constructed bracelets. Mary Lee Hu, *Bracelets #43, 44, 45*, 1989. 18K and 22K gold. Photograph by Richard Nicol.

Earrings. Cathleen Bunt. Pink, green and watermelon tourmalines, diamonds and 22K gold.

Ira Ono, *Voo Doo Monkey Pin*. Hand-colored Xerox, mixed media. 2½" (6.3 cm) tall. Photograph by Ron Ratkowski.

Thomas Mann, *Number 5*. Brass, bronze, silver, nickel, Lucite and found objects. Photograph by Will Crocker.

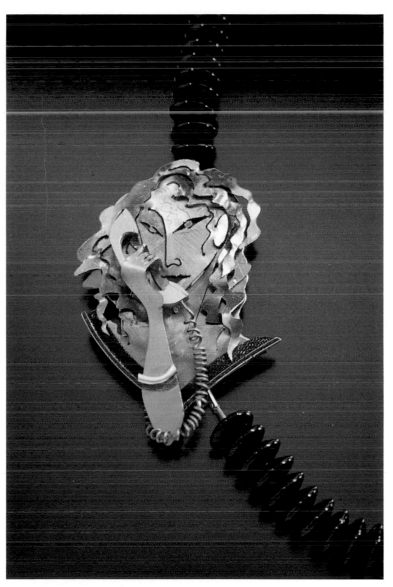

Necklace. Enid Kaplan, *Hold the Line*, 1988. Sterling silver, niobium, brass and onyx.

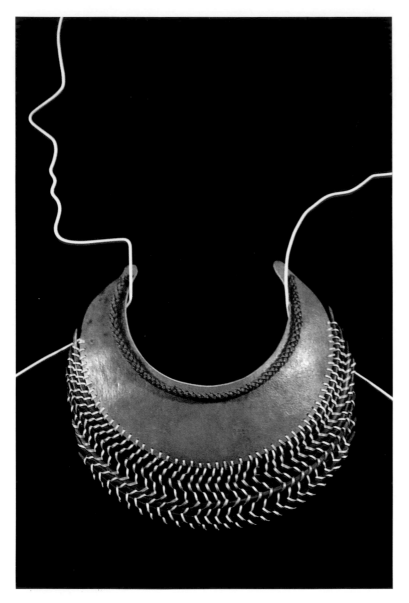

Coiled neckpiece. John McGuire, *Lunula*. Hand-prepared black ash splints, fern fronds, calabash, Norfolk Island pine cone and suede.

Brooch. Robin Kranitsky and Kim Overstreet, *I'm Late, I'm Late*, 1989. Silver, copper, Micarta, postcard fragments and found objects. $2\frac{5}{8}$ x $2\frac{3}{4}$ x $\frac{5}{8}$" (6.6 x 6.9 x 1.6 cm). Photograph by Robin Kranitzky.

Neckpiece. Hiroko and Gene Pijanowski, *Oh! Am I Precious No. 3*, 1986. Mizuhiki (paper string) and canvas. 9 x 21 x $\frac{1}{4}$" (22.5 x 52.5 x 0.6 cm).

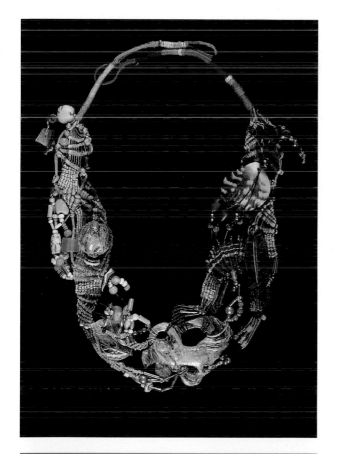

Above Left: Kathleen Williams, *Moonlit Mermaid*. Glazed clay (porcelain), waxed linen, embroidery thread, beads and shell.

Above: Pier Voulkos, *Short Woven Leaves Neckpiece,* 1992. Polymer clay. 10½" (26.3 cm) long. Photograph by George Post.

Left: Brooch/pendant. Larissa Rosenstock, *Summer.* Painted enamel, gold, pearls and diamonds.

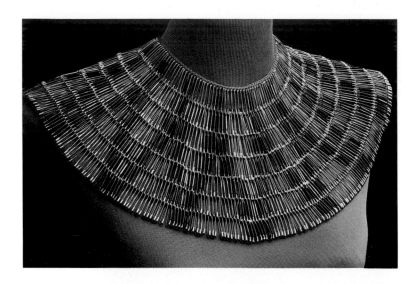

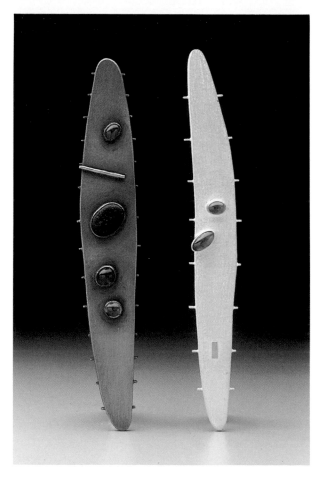

Above: Pin. Roberta Williamson, *Don't Say It—Just Wink,* 1992. Sterling silver and found objects. Pierced, soldered and bezel set.

Above Left: Crocheted neckpiece. Tina Fung Holder. Gold and silver safety pins and glass beads. Photograph by Jeff Bayne.

Left: Claire Sanford, *Pins Nos. 32, 36,* 1990. Sterling silver, 22K gold and stones. Each 5" (12.5 cm) long.

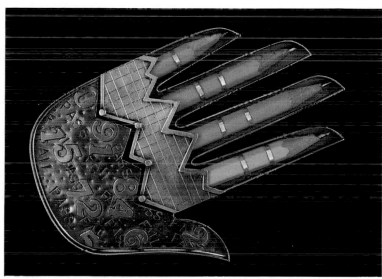

Kiff Slemmons, *Measure Up: To School,* 1991. Silver, brass and pencils.

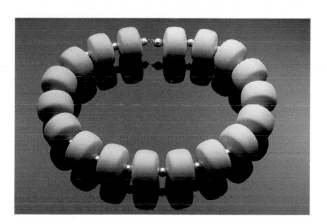

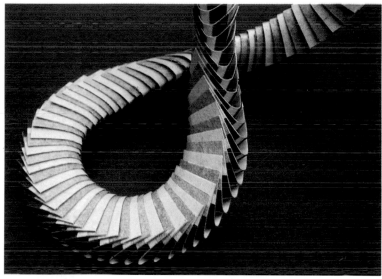

Top: Kris Eberhard, *Blue Wing Set.* Wet-formed, vegetable-tanned leather and acrylic paint.

Bottom: Neckpiece. Howard Newcomb. Porcelain beads, sterling silver clasp and spacer beads.

Necklace detail. Nel Linssen, 1989. Plastic-covered paper.

K. Lee Manuel, *Dragon Dream*, 1990. Feathers, acrylic and fabric paint.
Photograph by David Reese.

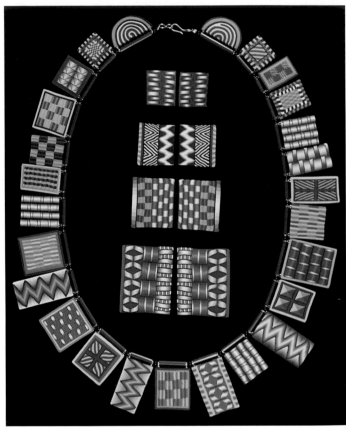

Necklace and four pairs of earrings. Steven Ford and David Forlano.
Caned polymer clay, black onyx beads and anodized aluminum
tubing. 21" (52.5 cm) long.

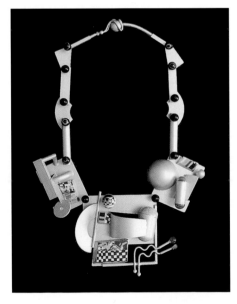

Neckpiece. Cynthia Chuang. Airbrushed
brass, porcelain semiprecious beads. 20"
(50.8 cm) long.

Fiber 5

We are accustomed to wearing fiber that has been made into clothing, but we rarely think about how it could be used to make distinctive jewelry. Because prehistoric people had easy access to plant and animal fibers, these materials were some of the first to be used for adornment. The many methods adopted over the years for making and decorating clothing (i.e., sewing, weaving, embroidery, appliqué, painting, coiling, crocheting and knitting) can be applied to jewelry making. Fibers are soft and responsive and offer great variation in color, pattern and texture.

Materials for making fiber jewelry are available at fabric stores or, since so little is needed, remnants from sewing projects or recycled cuttings from old clothing can be used. Materials such as beads, buttons, sequins and feathers can be added for embellishment. The sewing machine is a handy ally for putting these materials together, but the patient at heart may prefer to sew by hand. Some techniques do not require sewing; the materials can simply be glued.

Ruth Nivola, *Three Icons*, 1992. Metallic and silk yarns crocheted, whipped and hammered flat. 14 x 12½" (35.6 x 31.8 cm).

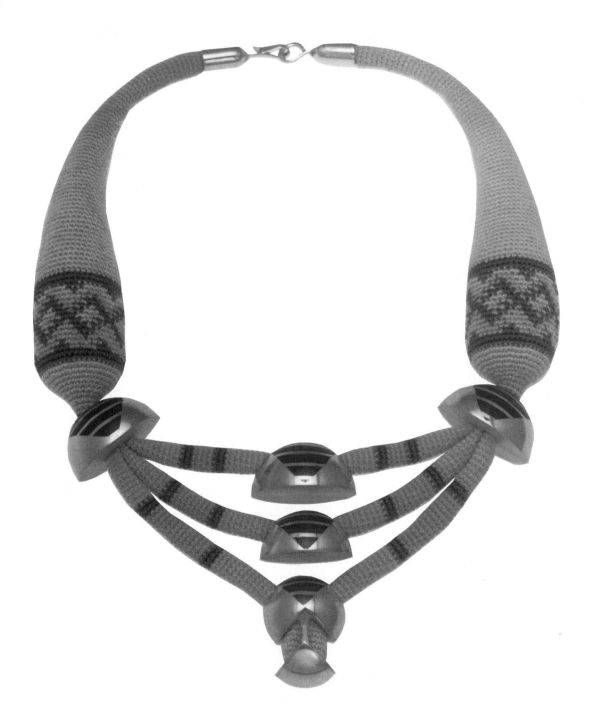

Cotton necklace executed in the single crochet stitch. Variations in diameter were achieved by increasing and decreasing the number of stitches. Linda Magi. Cotton with copper and sterling silver beads.

Machine-Sewn Appliqué

An interesting array of fabrics can be sewn onto a supporting background to create a minute collage distinguished by its variety in images, materials and surfaces. By using the sewing machine's zigzag stitch, diverse elements can be unified into one coherent image. The thread itself becomes an important linear element in the design. This miniature appliqué is a unique form of jewelry that can include fabric to compliment a particular outfit or a swatch from something, such as the hem of a wedding gown, that has a special meaning to the wearer.

Tools and Materials

You will need the following tools and materials for your machine-sewn appliqué projects.

- **fabric**
- **an iron**
- **scissors**
- **sewing machine with zigzag attachment**
- **thread**
- **sewing needle**
- **beads, charms, feathers, etc.**
- **fabric glue or Tacky Glue**
- **closures, such as findings and Velcro**

Pin made by the author from an image cut from fabric that was machine sewn to a felt backing. The small bells were sewn on by hand.

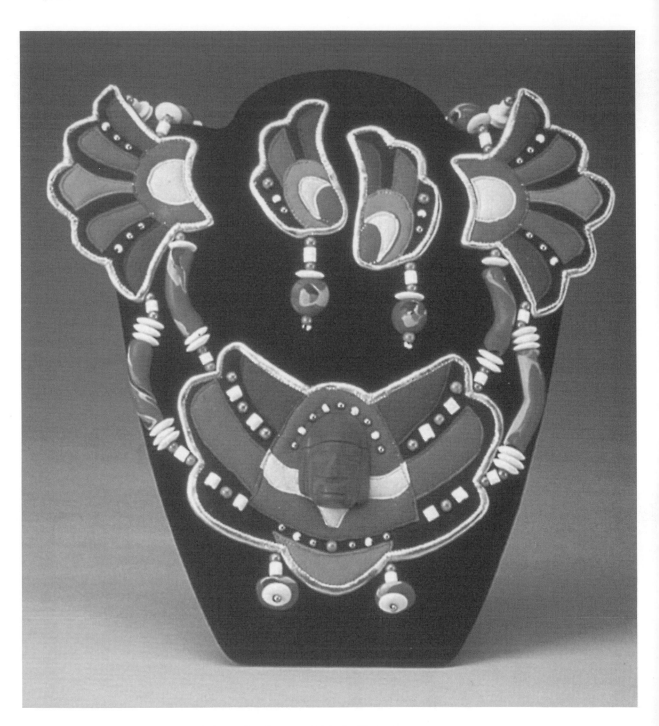

This necklace and earring set was made by sandwiching wool felt, double buckram, quilt batting and fabric together, with fabric shapes to be glued on top with white glue. This sandwich of materials was quilted together with an industrial-strength sewing machine. The outside edge was trimmed and bound. Beads, some handmade from polymer clay, were attached by hand. Pamela Hastings.

Prints, embroidered fabric, needlepoint, felt, metallics, silks (such as a scrap from an old kimono), lace, yarn and ribbon are some of the many materials to consider when you plan your design. When choosing fabrics, check both sides of the cloth. You may find that the "wrong side" is the right side for you. In addition to found prints, you can create your own fabric designs with acrylic or fabric paint. Metallic or waterproof paint markers are useful for adding accents to your painted motif.

Begin working on a background fabric that is at least ½" (1.3 cm) larger than your appliqué design. When picking a background fabric, choose material that is thick enough to give body to the work. Thin felt, for instance, is sturdy and makes an excellent background. Felt is especially easy to work with; it leaves a clean edge that will not fray when cut. Some of the background will show in the final piece, so choose a color that compliments your design.

After you have cut out your fabric shapes, iron any fabric that is not already flat. Use fabric or Tacky Glue to adhere the pieces to the background. If you glue the fabrics close together, two juxtaposing edges can be sewn at the same time. Smooth the glued fabric down with your hands until it lies flat. After the glue has dried, you are ready to sew the fabric onto the background.

Using the zigzag setting on the sewing machine, sew the fabrics to the background. Set the machine on the setting that produces close, wide stitches so that the thread will cover the edges of the fabric. You may wish to sew the fabrics together a second time if the thread has not covered the edges to your satisfaction. You will find that the zigzag stitch uses a lot of thread, so be sure to purchase enough thread in the color(s) you need.

When all sewing is completed, cut the background fabric to the shape of your design, leaving an extra ½" (1.3 cm) all around. Fold the extra ½" (1.3 cm) under and glue it down with Tacky Glue or fabric glue. After the glue has dried, cut a piece

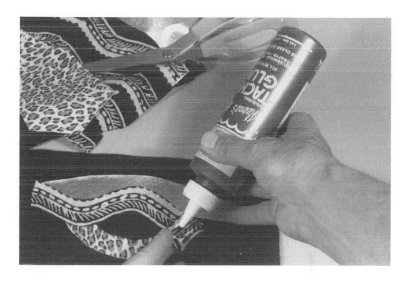

Shapes of fabric are first glued to a felt backing.

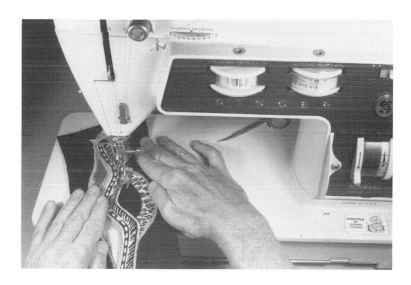

They are then sewn on using the sewing machine's zigzag stitch.

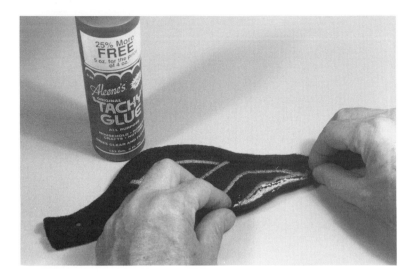

The edge is folded under and glued to the back.

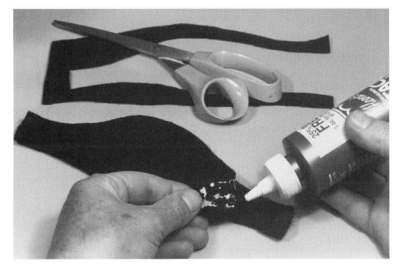

A piece of felt is glued to the back.

of felt the same size as the design less ⅛" (0.3 cm) and glue it onto the back of the work to give it a finished appearance.

At this point, beads, feathers or other decorations may be added by hand with a needle and thread. Complete the piece by gluing or sewing on any necessary findings. Velcro can be used to close a bracelet or necklace. Sew around the edge of the Velcro to secure it in place.

The completed cuff bracelet. The closing was made by sewing a strip of Velcro to each end of the bracelet.

A machine-appliquéd pin made by the author. Beads were sewn by hand. Color was added with fabric paints.

Neckpiece. Emelyn Garofolo. Machine zigzag stitched over cotton cord as well as straight stitched without a backing.

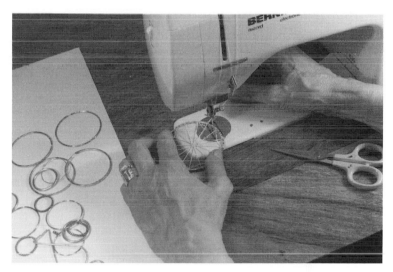

This "spider's web" is being sewn on the machine using both the straight and zigzag stitches. A metal ring defines the outer shape.

A sewing machine may also be used to create designs with thread that is not backed by fabric, or to cover cord with colored thread.

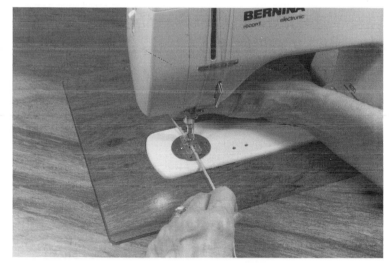

The zigzag stitch can be used to cover cord with colored thread. The machine's top thread and the bobbin thread cover both sides of the cord in a single pass.

Painted Silk

With shaped silk as your background and fabric paints as your painting medium, you can create elegant pins, neckpieces, tie tacks, barrettes, bracelets or earrings. Thin plastic cut from a disposable plastic plate provides the support over which the silk is stretched. Add some polyester stuffing for dimension and you have a pleasing form on which to paint. The backing is covered with a similar construction less the stuffing, giving the entire work (front and back) a finished look.

16-mm black crepe de chine silk is recommended for this technique for its durability and its gently textured surface, which is highly receptive to paint. The black silk provides a stark background that intensifies the brilliant colors. Use any good quality fabric paint that is water soluble and waterproof when dry (see *Sources of Supply*, page 156). The pearlescent and metallic colors are particularly effective. Paints can be mixed to create a wide range of wonderful colors. You may also wish to experiment with other background materials.

To begin working in this medium, cut an oak tag template for the background shape. Trace this form twice with a marker onto a plastic plate or another thin, semirigid plastic. (Cardboard can also be used for this purpose.) Use one of these for the top and the other for the backing.

This same template is then used to make two silk shapes. Since each will be wrapped around one of the plastic forms and glued around the back, you will need to add a ½" (1.3 cm) of fabric all around the template. When working on black silk, use a light-colored pencil to first trace the template. Then draw a second line ½" (1.3 cm) outside the first and cut along it. The second piece of silk should be the mirror image of the first, so that the drawn guideline is always on the inside and invisible in the final product.

Tools and Materials

You will need the following tools and materials for your painted silk projects.

- **scissors**
- **oak tag**
- **thin marker**
- **light-colored pencil**
- **disposable plastic plates**
- **silk**
- **polyester filling**
- **toothpick**
- **Tacky Glue**
- **fabric paints**
- **small watercolor brush**
- **water**
- **sponge**
- **findings, etc.**

Pin and earrings by the author. Painted and stuffed silk.

A pattern is traced twice onto a plastic disposable plate and onto silk. A ½" (1.3 cm) border is added to the traced forms on the silk. All four shapes are cut out with scissors.

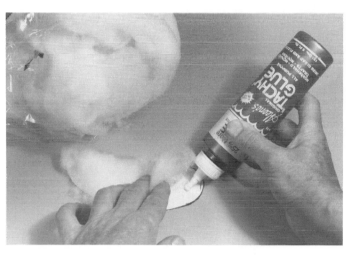

Polyester filling is glued onto one of the plastic forms.

Use Tacky Glue to attach a thin layer of polyester filling to one of the plastic forms. Then cover the form with the silk and turn it over. Stretch the silk tightly over the form and then glue it down. Repeat the same procedure on the second form, this time leaving out the filling. When both forms are dry, glue their backs together. If you are making a necklace, glue the hanging cord between the two layers at this time. Be sure to position the cord so that the necklace hangs gracefully.

When the glue is dry, use water-soluble fabric paints to apply your design. If needed, thin the paints with water. It is important to relate the painted image to the background shape. Add any necessary findings to complete your piece.

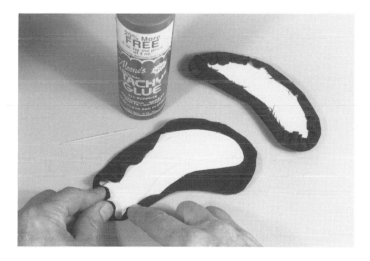

The silk is stretched around the plastic shape and glued onto the back. The second form is fashioned in the same manner, minus the filling. The two covered shapes are glued together, wrong side to wrong side.

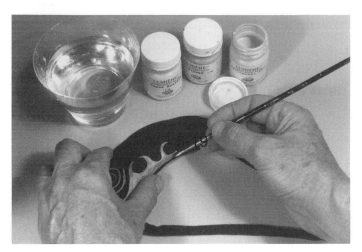

A fine brush is used to apply a design in fabric paints.

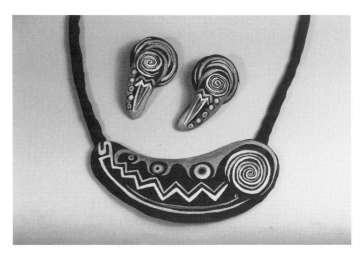

The completed neckpiece with matching earrings.

This brooch was constructed in a manner similar to that shown in the previous series of photographs. Barbara Allen, *Here Comes the Bride*. Satin fabric, a photocopied image (the bride) that was transferred to the fabric and hand-tinted with watercolors. Framed in handspun nylon stockings with faux pearls. Photograph by Richard W. Allen.

Coiling

Brooch. Marylou Higgins. Nu-gold wire, pierced and sawed Nu-gold sheet, plastic sheet, beads, 1-ply wool yarn coiled around 4-ply yarn.

Tools and Materials

You will need the following tools and materials at hand when coiling fiber.

- **florist wire**
- **string, yarn, embroidery thread, etc.**
- **scissors**
- **sewing needle**
- **stones, crystals, found objects, natural objects, etc.**
- **findings**

The method used for coiling in fiber is similar to the process described in the metal section of this book. There are, however, a few differences between the two methods. Since the string used in the fiber version of this technique is not stiff enough to hold in place on its own, you have to coil in a manner that secures the ends. In addition, a needle is needed to take a stitch between rows of coiling.

The following process photographs show how to coil in fiber. You may choose to use different materials for the core and/or the weft. The core, however, should always be thicker and stronger than the weft. Your work will progress quickly, so do not hesitate to experiment with unusual shapes and materials. Holes can be drilled through some materials before sewing them to the coiled shape. Other objects can be caged within the coiled form.

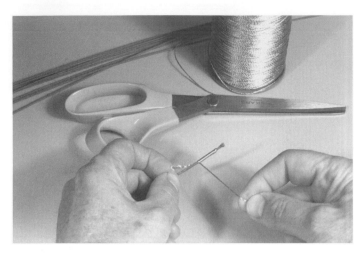

Begin coiling by simultaneously wrapping thread around florist wire (the core) and the end of the thread.

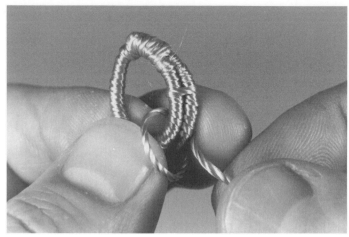

Bend the wrapped wire around in a circle. Wrap the end of the wire and the unwrapped wire together several times until they are joined and the end of the wire is concealed. Continue wrapping the uncovered wire, taking a tacking stitch around the previous row at intervals.

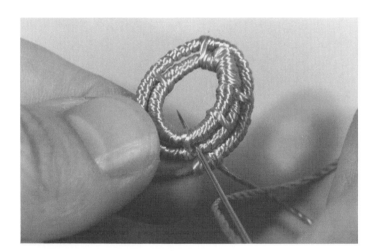

After the second row, you will need a needle to take the tacking stitch.

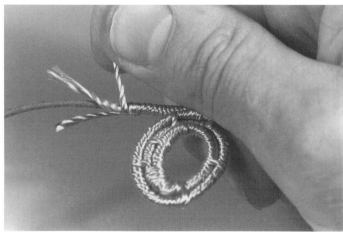

To end one thread and begin another, wrap the new thread around the wire as well as the end of the old thread and the beginning of the new thread.

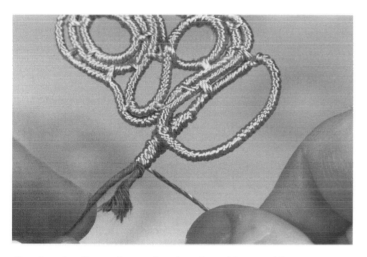

Continue bending and wrapping the wire, taking a tacking stitch wherever you wish to join the newly wrapped wire to the previously wrapped wire. If you run out of wire and wish to add more, overlap the new and old wires and wrap the thread around both.

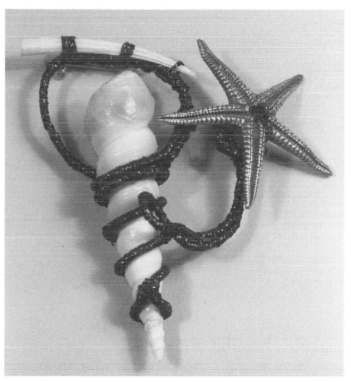

Pin. By the author. Shells, cast sterling silver starfish, metallic thread coiled over florist wire.

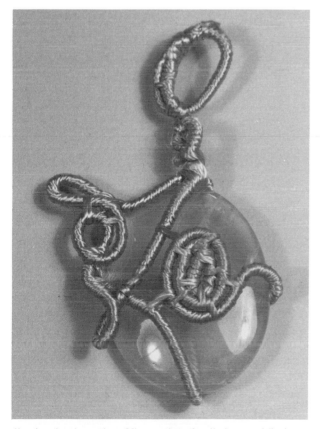

Pendant by the author. Viscose thread coiled around florist wire, trapping a rose quartz cabochon.

All of the elements that make up this piece were attached by coiling, including the pin finding.

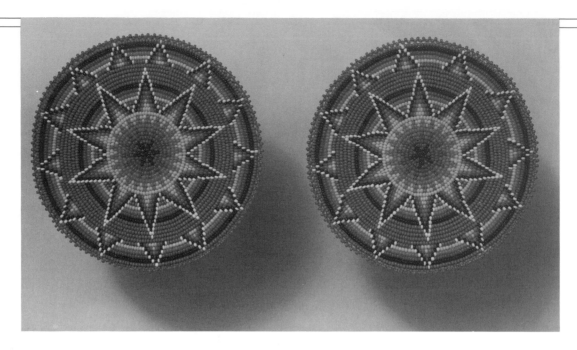

Medallions. Pamela Tartsah (Kiowa), 1977. Glass beads, each
4¼" (11.4 cm) in diameter. Photograph courtesy of the U.S.
Department of the Interior, Indian Arts and Crafts Board.

\mathcal{G}lass 6

\mathcal{G}lass does not usually come to mind when we think of jewelry making. It is most often associated with larger objects that are weighty and fragile. Unpleasant memories of accidentally breaking or being cut by glass might add to one's reluctance to work in this medium. However, if you follow a few precautions, glass can be a safe, "user-friendly" medium. When it comes to jewelry, glass offers a quality of beauty and permanence that is truly unique.

Glass is available in many forms, including tiny seed beads and sheets. Colored glass beads can be woven or strung to create designs and patterns. Glass in the form of thin, colored sheets can be heated in a kiln until the layers fuse together.

▌*Fusing*

The jewel-like quality of Gothic stained glass can be captured in fused glass jewelry. When pieces of glass are heated until they fuse and then cooled gradually, they blend into one solid, stable form. Whether you choose to use glass that is transparent, translucent or opaque, this material's reflectivity and vibrant colors are unmatched by any other medium.

The glass suggested for use here is easy to cut. If you follow a few safety precautions, you can work confidently, with the knowledge that glass is not as difficult to cut as most fear. Working with glass need not be a shattering experience!

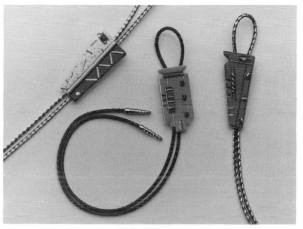

Pieces of glass have been assembled into three unique bolo ties and fused in a kiln. Bruce Pizzichillo and Dari Gordon.

Tools and Materials

You will need the following materials at hand when fusing glass.

- **Wasser Glass**
- **glass cleaner**
- **glass cutter with a carbide wheel**
- **cutting oil**
- **cutting surface (such as the Morton Surface)**
- **steel-edged rule (optional)**
- **hand broom**
- **running pliers (optional)**
- **grozing pliers (optional)**
- **carborundum stone (optional)**
- **white glue (optional)**
- **ceramic overglaze with small brush (optional)**
- **fusing or enameling kiln**
- **primed kiln shelf**
- **findings**
- **epoxy glue**

Choosing Glass

Because weight is a limiting factor, Wasser Glass is recommended for making fused jewelry. Wasser Glass is approximately 1/16" (0.2 cm) thick. This is significantly thinner than conventional stained glass. Wasser Glass is available in a wide range of colors, including primaries, pastels and patterns. Bullseye also manufactures a thin glass that is good for fusing. Other types of glass may be used if weight is not an issue; however, it is essential that the different types of glass be compatible.

Compatibility is determined by the rate at which different glasses expand and contract as they are heated and cooled. If two pieces of glass do not expand and contract at the same rate, they are non-compatible and are thus vulnerable to cracking. For example, if you fuse two glass fragments from a single soda bottle, the work will be stable as long as no other glass is fused to it. Once you add glass from another bottle, you are courting trouble. Even if the piece survives firing, it is likely to crack at some future time. If you work exclusively with Wasser Glass, you do not have to concern yourself with compatibility, because all Wasser colors are compatible.

Cutting Glass

Clean glass cuts best. Before cutting, glass should be thoroughly cleaned with glass cleaner or soap. Handle the glass as little as possible to avoid transferring oils from your hands to the glass.

An excellent surface upon which to cut glass is the Morton Surface. The Morton Surface is a plastic grid made up of small cells that collect chips as you work, thus keeping the working surface free of dangerous glass splinters that can not only cut the worker but can scratch the glass. A hand broom is helpful for sweeping away any loose chips that are not caught in the grid.

Glass is cut by first scoring its surface with a glass cutter and then breaking along the score. A glass cutter with a carbide wheel is preferable to one with a steel wheel. The glass cutter is held between the index and middle fingers and is supported on its underside by the thumb. It is best to score standing up. Lean gently on the cutter; it is not necessary to press hard. The pressure should come from the shoulder down through the arm and into the fingers.

Lubricate the glass cutter periodically by dipping its tip in nontoxic cutting oil. Cut freehand or along a steel-edged rule or around a pattern made from sturdy paper, such as oak tag. Score with one continuous stroke instead of going over a line several times. A line that is scored more than once will

most likely shatter when it is broken apart. Always score all the way from one edge of the glass to the other. Some shapes will require several cuts. Beginners should avoid cutting shapes with deep, concave scores. The simpler the shape, the easier the cut. Clear window glass is easy to cut and makes good practice glass. It is often free for the asking. School custodians are often good sources of scrap glass left over from replacement windows.

Glass can be broken at the score by several methods. The most direct involves breaking the glass with one's hands. The proper placement of the hands is important for reasons of safety. Place one hand on each side of the base of the score, with the thumbs parallel to the top side of the score and the fingers forming fists and parallel to the underside of the score. When one's hands are in this position, they will not be cut when the glass is pulled apart.

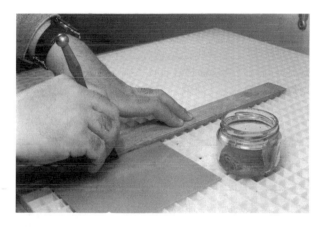

A glass cutter that has been lubricated in cutting oil is used to score the glass. The plastic grid beneath the glass is a Morton Surface. It collects glass chips and keeps them out of harm's way.

This photograph shows the proper position of the hands for breaking glass along a scored line.

A running pliers is used to break glass along a straight, scored line.

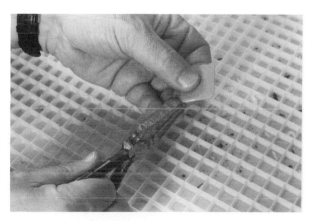

The edges are rounded with grozing pliers.

To snap the glass apart, pull down and out away from the line so that the index fingers come up and away from the score. If this does not work, the score can be tapped gently with the ball end of the cutter. This is accomplished by placing the glass score side down on a hard, flat surface and tapping the top of the glass along the scored line. Once the score breaks through under the tapping, coax the break along by tapping it until it cuts through the entire scored line. At this point, the glass should pull apart with ease.

Another method for breaking apart straight, long scores is to use running pliers. Simply line the pliers up with the score and squeeze. The pliers will break the glass at the score if the score was made correctly.

Grozing pliers can be used to round corners by nibbling them away. Rough edges left from cutting or grozing may be ground smooth with a wet Carborundum stone or a glass grinder.

SAFETY NOTE: Use a face shield on the glass grinder for protection from flying glass. Goggles must be worn at all times when cutting glass. Keep the cutting surface free of glass splinters.

Gluing and Decorating

After cutting the glass, arrange the pieces and glue them together with white glue. (This will prevent them from moving around in the kiln.) Tacking glue manufactured specifically for this purpose is also available. You can often get away without gluing, but occasionally will find that the kiln has rearranged your design if you do not tack everything down. Allow the glue to dry before firing.

To decorate the surface of the cut glass sheet, stringers, lumps, confetti, powdered enamel and ceramic overglaze may be added. Stringers, lumps and confetti are glass in the form of strings, lumps and tiny circles. Enamel is basically powdered glass and small quantities of it can be sprinkled over glass before it is fired. **SAFETY NOTE: Use only lead-free enamels.**

Overglaze is applied with a fine brush or dabbed on with a toothpick. Use it as it comes from the tube or, if necessary, thin it with water.

A wire loop long enough to be partially sandwiched between two layers of glass can be fused within the piece. After the glass is fired, the loop

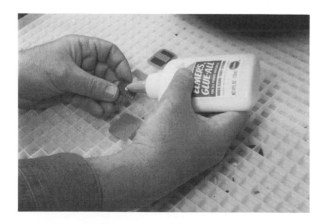

The cut glass elements are glued together to prevent them from shifting in the kiln.

Ceramic overglaze is added for decorative effect.

will be trapped within the glass, allowing the piece to be strung on a chain, leather thong or cord.

Firing

With the glass glued together, decorated and thoroughly dried, the work is ready for firing. A fusing or an enameling kiln is used for heating glass to fusing temperature. Small kilns are ideal for fusing jewelry and are also a great deal less expensive than the much larger ceramic kilns. Small kilns can be purchased from a large art supply company or a glass crafting store. It is recommended, though not essential, that you use a kiln equipped with a pyrometer to measure the interior temperature. Pyrometric cones may also be used for this purpose. Their use is described in Chapter 2.

SAFETY NOTE: A kiln should be placed on a fireproof surface, away from combustible materials. Use welder's gloves when working at the kiln. Protect eyes from repeated exposure to the red-hot heating elements that emit infrared radiation by wearing infrared goggles or goggles with a shade number of 1.8 to 3. Vent the kiln with a canopy hood or by placing the kiln directly in front of a window equipped with an exhaust fan.

To fire your work, place it on a kiln shelf that has been coated with shelf primer to prevent the glass from sticking. (Shelf primer made specifically for glass is recommended.) Use a brush to apply three even coats of the primer. Each coat should run perpendicular to the previous one. When the primer is thoroughly dry, the glass is placed on the shelf and into the cool kiln.

When firing the kiln for fusing, you must follow a specific sequence of temperature changes that brings the glass up to fusing temperature and then cools it slowly to prevent cracking. This gradual cooling, called *annealing,* is an essential step in the firing process and will be discussed in the following

The glass is put into the cool kiln and gradually heated to fusing temperature.

section. Each kiln fires differently, depending upon its type and size. It is, therefore, impossible to give standard firing times.

The following schedule is identical to that used for the firing shown here: Turn the kiln on low with the glass in place on the kiln shelf and the kiln door left slightly ajar (approximately ½" (1.3 cm)) for venting. Bring the temperature up gradually until it reaches 1,000°F, at which point you can close the door. After the temperature inside the kiln reaches 1,300°F, it is essential to keep a watchful eye for the precise point at which the glass melts to the desired degree. Wearing infrared goggles, look through the peephole (if your kiln has one) or crack the door just enough to see inside the kiln. Remember that each time you open the door even a crack, the temperature inside the kiln decreases, so peek as quickly and infrequently as possible. You can determine that the glass is fused when the edges become rounded. Avoid overfiring, for overfired glass will melt into a puddle. The fusing temperature of glass is approximately 1,450°F. This will

vary, depending upon the thickness of the glass, the number of layers and the type of glass.

As soon as the glass is fused, you are ready to begin the cooling process.

Annealing

The fused glass must be annealed to prevent it from cracking. Cracks are an inevitable result of cooling too quickly. When the glass reaches fusing temperature, hold the kiln door open until the kiln cools to 1,000°F. (This temperature drop can occur quite rapidly.) Close the door, lower the kiln setting and maintain this temperature for at least 20 minutes. Then turn off the kiln and allow it to cool gradu-ally to the point where the glass can be removed comfortably with one's bare hands. Do not give in to temptation and open the kiln door or remove the glass while it is still hot, or it will shatter. Haste will make waste!

Finishing

Findings may be added with two-ton clear epoxy glue. This glue comes in two parts that, when mixed in equal amounts, will cure and harden. It makes a particularly strong bond between the glass and the metal findings. A toothpick makes a handy applicator for applying glue to the glass.

Findings are added with epoxy glue.

The completed earrings.

Beaded Loom Weaving

Although weaving with glass sounds impossible, it is really quite simple. By using tiny glass beads called "seed beads," you can create delicate pictures. Native Americans have developed this technique of loomed beadwork into an art form ever since they were introduced to the seed bead by Europeans who traded them for Indian goods. The elaborate and colorful patterned weavings for which Native Americans are well known demonstrate a high degree of craftsmanship.

Tools and Materials

The beadwork supplies listed here are simple, inexpensive and readily available at art and hobby stores.

- **graph paper**
- **colored pencils or markers**
- **beading loom**
- **colored seed beads (one size)**
- **small scissors**
- **Nymo thread (nylon), suggested sizes "D" and "B"**
- **beading needles**
- **beeswax (optional)**
- **findings**

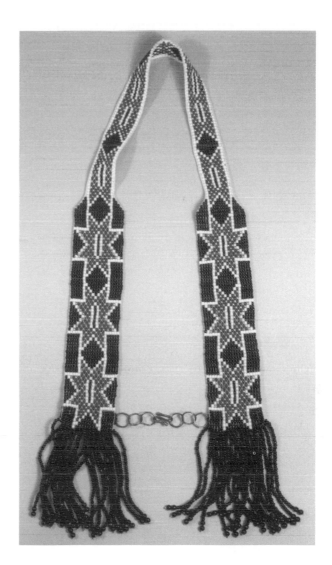

In this picture, the artist makes good use of positive and negative space by repeating the star pattern. Polly Kurasch. Loom-woven seed beads with beaded fringe.

Designing

The underlying gridlike structure of loomed beadwork makes such pieces simple to design using graph paper. Each box on the paper can correspond to a single bead. The colors can be noted with markers or colored pencils. Although beads are, in actuality, more elongated than the squares on standard graph paper, the general effect can be

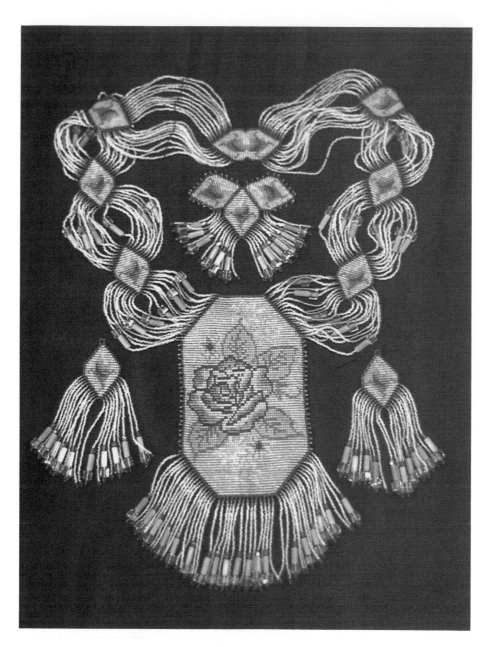

Peggy Sue Henry, *Roses, Asters and Rose Buds,* 1993. Glass
seed beads, satin glass beads and faceted Austrian crystals.

tic or abstract—can be adapted to loomed bead-work. A small figure or scene can be very precious when "painted" in beads. Using beads of contrasting colors can impart a dramatic effect to your work.

The Loom

Any structure that will hold the warp (the threads that run lengthwise) taut is suitable for use as a loom. Even a cigar box, slotted on opposite sides to hold the warp, will do for basic work. There are several commercial looms that can be purchased from crafts suppliers. These looms are, however, often inadequate for large work and they do not always maintain even tension on the warp.

A perfectly suitable loom can be made using three pieces of board, a few nails and two hair combs. Such looms are inexpensive and easy to build. To construct your own loom, simply cut a 1" (2.5 cm) thick pine board that is approximately 36" (91.4 cm) long x 5" (12.7 cm) wide. (The loom can be cut to any length, provided it is at least 3" (7.6 cm) longer than the longest beaded piece you plan to loom.) Before you nail or screw on two end pieces (approximately 4" (10.2 cm) high x 5" (12.7

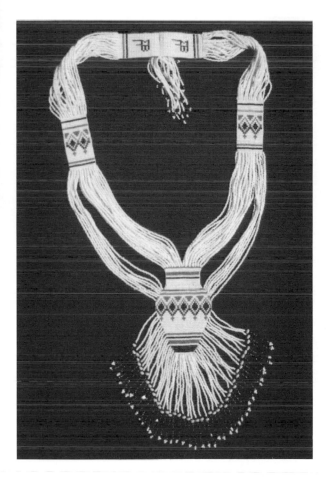

Frieda Bates. Glass seed beads woven on nylon thread.

viewed. Special bead-size graph paper, which is more in line with the actual proportions of the bead, is also available. When creating a repetitive pattern, you need only draw the pattern once or twice to observe the overall effect.

Patterns can also be designed using a computer graphics program. These programs often include a grid tool that will lay out a grid to your specifications. The fill tool allows you to add color.

Although the traditional Native American designs are symmetrical, there is no reason why you cannot work asymmetrically and create a design that suits your unique style. Do not limit yourself to traditional patterns. Any shape—realis-

Bead looms. The loom in the background was made from three pieces of wood and two hair combs. The two looms in the foreground were purchased from a crafts supply company.

cm) wide) to the ends of this board, attach a comb to the top of each end piece. Choose combs with teeth that are equally spaced and whose spacing approximates the size of the beads you are using. To attach the combs, drill two holes in the base of each comb. Using these holes, nail one comb to the top of each end piece. The teeth should protrude approximately ½" (1.3 cm) above the top of the wood.

After you have nailed or screwed the two end pieces with the mounted combs to the long board, complete the loom by hammering a large-headed nail in the center of the bottom of each end piece. These nails will hold the thread as you warp your loom. A light sanding of the wood will ensure a smooth finish and eliminate splinters.

Warping the Loom

Starting at one end of the loom, string the warp by tying a knot around the nail. Size "D" Nymo thread is recommended for the warp. You will need as many rows of thread as there are beads in the width of your design, plus one. It is suggested that the threads at either side of the warp be doubled for added strength. Working so that the completed warp will be centered on the loom, draw the warp thread back and forth through the teeth of the comb and around the nails until the loom is warped and ready for beading. Pull the thread taut as you work to maintain a uniform tension. The warp should spring back when pressed gently. When you have finished warping the loom, tie the end of the warp thread to the nail.

Weaving

Seed beads are available in a variety of sizes and colors. The higher the number, the smaller the bead. Seed beads can be purchased loose or prestrung. Prestrung beads are easier to transfer onto a needle than loose beads that have to be picked up individually. All beads should be the same size to produce a solid, uniform surface. An egg carton, muffin tin

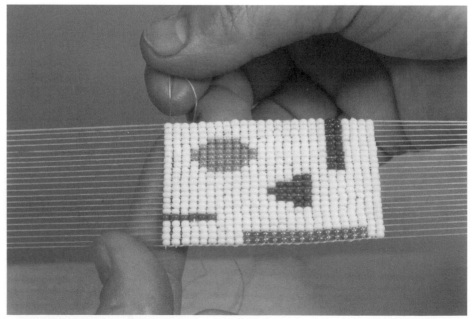

The beads are strung onto the nylon thread and pushed up from below the warp so that each bead is positioned between two warp threads. In this photograph, the thread is being passed through the beads a second time and is traveling over the warp threads.

or sectioned box can be used to hold the different colored beads.

To begin weaving, tie the weft thread to an outside warp thread. The weft thread holds the beads and travels back and forth perpendicular to the warp. Do not start beading at the base of the warp: instead, leave enough warp to tie the ends together or, if you so desire, to finish the work by creating a beaded fringe. For a fringe, you will need to leave at least twice the length of the fringe plus two inches at each end. (See *Finishing,* on this page.)

Nymo thread size "B" is suggested for the weft. To prevent tangling, you may wish to rub the thread over beeswax. Special long, thin needles made specifically for beading are used to string the seed beads. The needle size should correspond to the size of the bead. For example, a #12 needle can be used for size 12 and larger beads. The needle should be thin enough to pass the thread through the bead at least four times.

Thread the beads in order according to the first row of your design as it has been planned on graph paper. Discard any oddly shaped beads. Run the row of threaded beads under the warp threads and push them up so that each bead takes its place in the space between them. Holding the beads in place with your finger, run the weft thread through the same beads, this time passing the weft in the opposite direction and above the warp threads. When the weft thread is pulled, it will lock the beads in place. Do not pull the thread too tightly or it will distort the beadwork. The first row is the most difficult, because you are spacing the warp to the exact size of your beads. Continue adding rows in this manner as you follow your design plan.

If you run out of weft, weave the end back into the work through several beads. End the thread in the middle of a row rather than at the edge and cut it flush with the beadwork. Begin the new thread by first weaving it through a few of the previous beads. (Again, begin in the middle of a row.) Continue adding new rows of beads in the manner described previously.

Finishing

When the beading is completed, cut the warp off the loom. The loose ends may be woven back into the beadwork through two or three beads in each of several rows. In this manner you will weave the thread upward into the beadwork rather than all the way across a row. This avoids threading through the same beads too many times as you finish off the warp threads.

Another way to finish your work is to back it with leather. To accomplish this, tie the warp threads together in groups of two or three as close to the end rows of beads as possible. Tuck the threads under the beadwork before sewing it to a leather backing. Use leather, such as thin suede, that is soft and thin enough to sew through.

Perhaps the most decorative way to complete the beadwork is to add a beaded fringe by threading a needle with each warp thread and stringing beads to the desired length. Bring the warp thread around the outside of each bottom bead and back through the rest of the fringe beads. Weave the loose end of the warp thread back up through the piece as described previously. Cut off any loose threads as close as possible to the beadwork.

Finish by sewing on hooks, snaps, Velcro or other findings that are needed to make the piece wearable.

Beading

Using this technique, beads are combined on wire or thread without the use of a loom. Although this technique may seem complex the first few times you attempt it, it will become second nature with practice. The earrings demonstrated here are traditional, but you may also use this technique to create large collars and more intricate beaded earrings. It is suggested that you start by following the directions exactly as they are presented and then, when you feel comfortable with the technique, branch off on your own and create original designs.

The drawings on pages 128 and 129 illustrate how seed and bugle beads can be combined to create an earring.

Tools and Materials

You will need the following materials at hand for your beading projects.

- **seed beads (one size)**
- **bugle beads (with the same diameter as the seed beads)**
- **beading needle, suggested size #12 or #13**
- **Nymo thread, suggested size "0" or "A"**
- **small scissors**
- **findings**

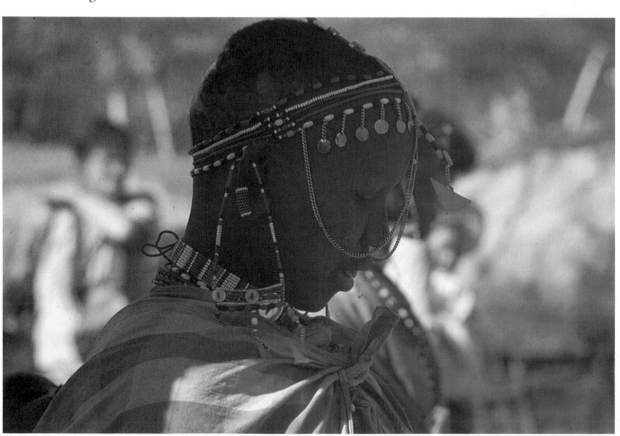

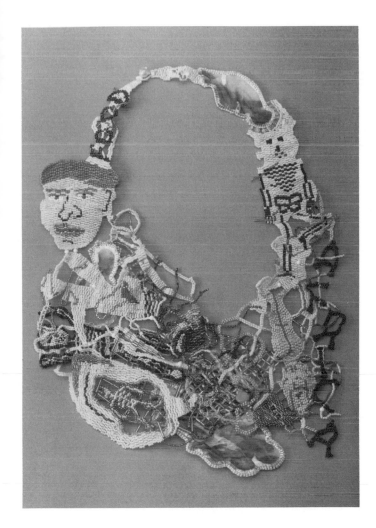

An African collar fashioned from wire and seed beads.

Above: A powerful political statement was expressed in this neckware. The more you examine this piece, the more you see. Joyce Scott, *Hunger.* Neckware. Wire, thread, glass beads and photographs. Photograph by Kanji Takeno.

Left: A Masai woman from Kenya adorned with traditional beadwork.

Right: This small beaded figure can be made from one continuous piece of thin wire, glass seed and bugle beads. A larger bead should be used for the head. Animals and abstract forms can be created in the same manner.

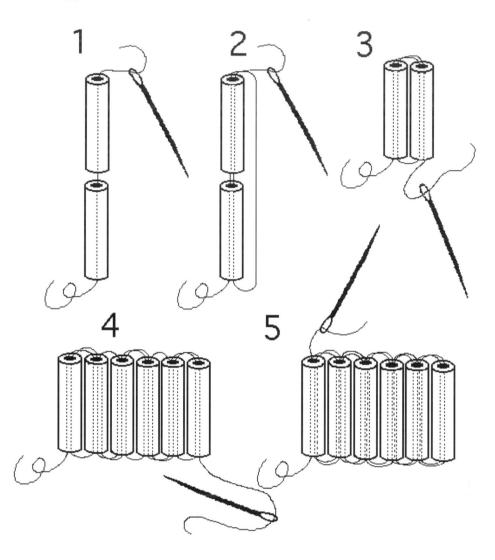

1: The beading needle is threaded up through two bugle beads and the beads are pushed down to approximately 3" (7.6 cm) from the end of the thread.

2: The needle is threaded through a second time, once again going up through the two beads.

3: When the thread is pulled the beads will lay side-by-side. Do not pull the thread too hard. The beads should lay close together and flat.

4: Add a third bead and first pass the needle down through the last bead and then back up through the bead you have just added. Then add a fourth bead, this time passing the thread up through the last bead and down through the bead you have just added. Thus the beads will alternate, one being added from the top of the last bead and the next from the bottom. Continue adding beads in this manner until you have reached the desired width.

5: Thread up and down, back through all of the beads to reinforce them.

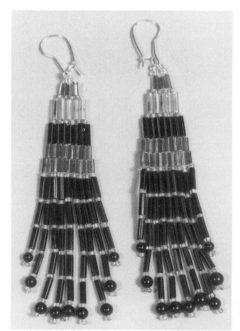

This pair of earrings is a variation on the earrings described above. The difference is in the number and type of beads used. By the author.

6: To add seed beads above the bugle beads, string on one seed bead with the thread coming up from the last bugle bead. Then pass the needle under the thread connection between the top of the first and second bugle beads. Go back up through the same seed bead to lock it in position. Add a second bead and repeat the process, again taking a stitch under the connection between two bugle beads (this time the second and third). Continue adding beads in this manner until you complete the row.

7: The next row of seed beads is also added by taking a stitch, this time under the connecting thread between two seed beads. With each row there will be one fewer bead added. The direction of the beading will alternate with each row. After adding a top row of two beads, string on six beads to form a loop from which the earring can be hung. Pass the thread through these beads a second time to close and reinforce the loop. When all of the beading is complete, an earwire can be slipped onto this loop so that the earring can be worn.

8: Pass the thread back down through the beads on the edge of the earring to place the needle in position for adding a fringe. The needle will now be at the bottom of the end bugle bead.

9: Thread together several seed and bugle beads for the first row of your fringe, ending the row with a seed bead. Pass the thread first around the outside of this bottom bead and then up through it. (This is the only bead on the fringe row that has only one thickness of thread passing through its hole.) Then pass the thread back up through the row of fringe beads and back up through the bugle bead on top. To start the next row, go down through the next bugle bead and repeat the process. At the completion of the last row of fringe beads, tie the thread to the nearby thread. Cut off the loose ends of the thread, and there you have it!

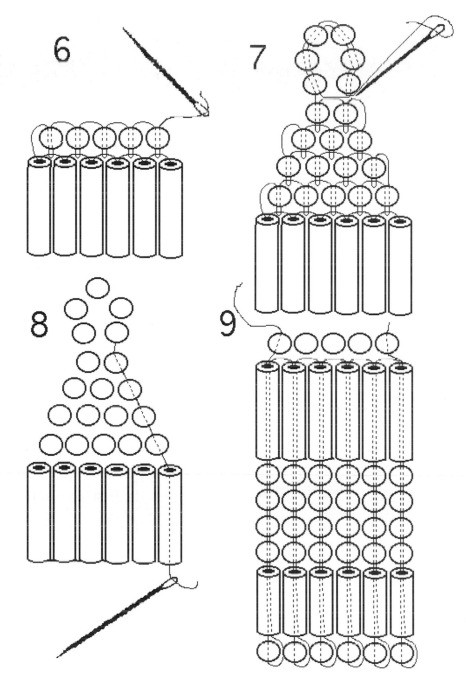

Wrapping Seed Beads Around a Core

A handsome, beaded choker is simple to make and can be worn as a necklace on its own or incorporated with a hanging pendant. A long version of this beaded necklace can be wrapped several times around the neck or worn as a long, single strand. A short version can be made into a bracelet. By stringing seed beads on a thread and wrapping the beads around a thick core, the core becomes completely covered with beads. You may choose to work with a single color, or to plan a more complex design by spacing different colored beads at intervals, thus creating a pattern.

Tools and Materials

You will need the following materials at hand when wrapping seed beads around a core.

- **seed beads**
- **soft core material, such as braided cord**
- **sewing needle thin enough to pass through the beads**
- **strong thread**
- **scissors**
- **end caps with hooks**
- **glue**

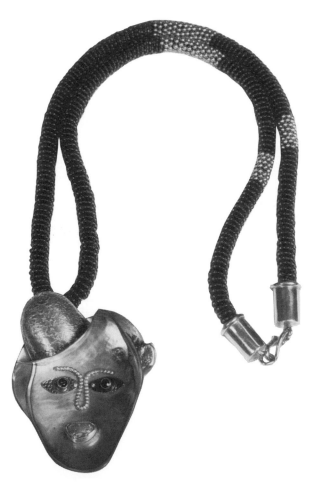

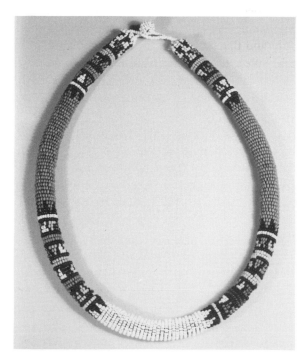

Above: African seed bead necklace. With careful planning, beads can be wrapped in such a way that they form a design.

Left: The beads from which this pendant is hung were wrapped around a core of nylon cord. By the author. Sterling silver and glass beads, abalone shell, opal, rubies, niobium and sterling silver.

Wrapping the Core

Begin by threading a needle and fastening the thread to the core with three overlapping stitches. Use strong thread the same color as the core. The core can be made from any thick material that is stiff enough to lend body to the beads, soft enough to allow the needle to pass through and flexible enough so that it will bend gracefully around the neck. Braided nylon cord makes an excellent core. The core should be at least ¼" (0.6 cm) thick. Leave at least ½" (1.3 cm) of bare cord at each end to be inserted into the end caps when the beading is completed. Excess cord can be cut off with scissors to fit into the cap.

With the thread well anchored on the core, string enough beads onto the thread so that it can be wrapped several times around the core. Then, after making certain that the beads are wrapped tightly and that no spaces have been left between beads, take a tacking stitch through the center of the core and then back again to lock the beads in place. At this point, the thread should be positioned just before the last bead, so that you can pass the needle through this bead in the direction that you are stringing. In this way, there will not be any gap between beads after taking a tacking stitch. Continue adding beads in this manner. Should you wish to add a pendant, do so at the midpoint of the core and continue wrapping beads to the end.

When you run out of thread, take three overlapping stitches through the core to end the thread and cut it off as close to the core as possible. Begin a new thread in the same manner, making sure not to leave any space between the last bead and the new beads. To ensure a consistent row of beads, pass the needle through the last bead in the direction of beading before stringing on new beads. After wrapping the desired length of core, take three overlapping stitches at the end and cut the thread.

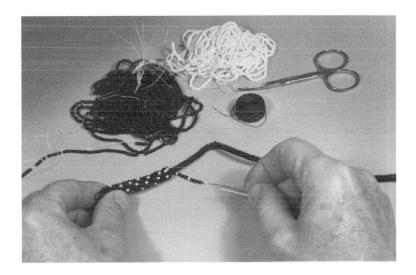

Glass seed beads are threaded on strong thread and wrapped around a cord core. A stitch is taken through the core at intervals to secure the beads.

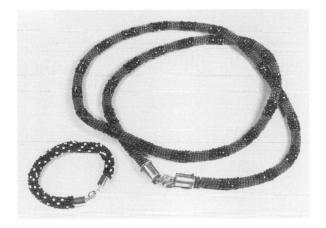

The completed bracelet and a longer beaded necklace.

To complete the necklace, glue the end caps onto the bare cord that you have left for this purpose. The caps should fit snugly against the beads. These caps not only finish off the ends neatly, but the hooks serve as a closing mechanism for the necklace.

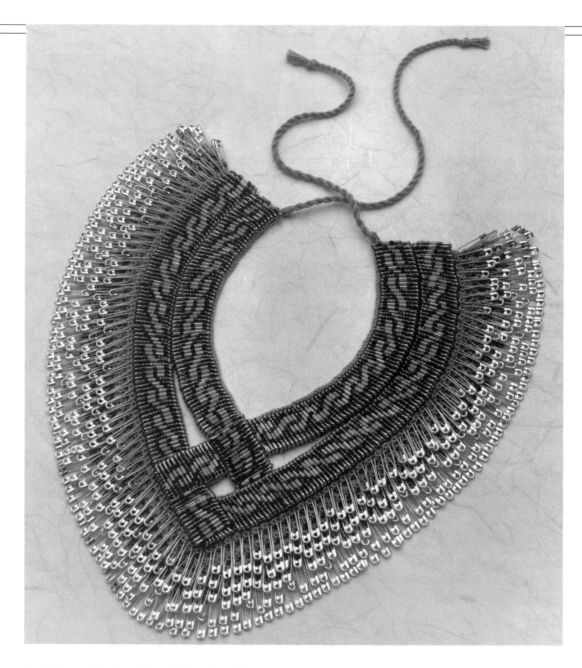

A striking combination of materials crocheted into a
neckpiece. Tina Fung Holder, *Neckpiece 58-1092*. Gold and
silver safety pins with glass beads. Photograph by Jeff Bayne.
Collection, American Craft Museum, New York.

\mathcal{A}lternative and \mathcal{M}ixed \mathcal{M}edia

\mathcal{P}erhaps the greatest opportunity for artistic invention is in the area of alternative and mixed media. Not only can techniques from all of the crafts be intermingled in nontraditional ways, but materials not usually associated can be inventively combined. The precious may have a seat next to the mundane, and the two may find themselves happy partners. Jewelers may find themselves working with materials never seen before in a piece of jewelry. All of the stops can be pulled out and anything is possible. New opportunities for color range, surface quality and design present themselves.

There is much precedent for the use of the found object in art. From the beginning of time, people have gathered materials from their surroundings and used them for self-adornment. The earliest peoples recognized that shells, bones, teeth,

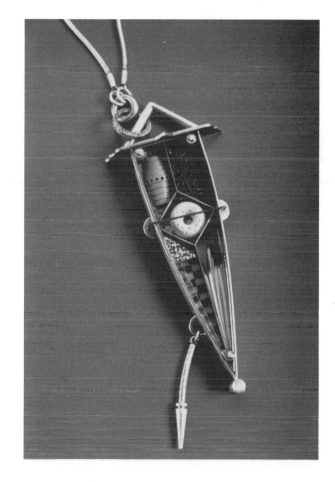

The artist uses his well-trained eye and masterful sense of design to unite these diverse materials into one harmonious work. Thomas Mann, *Collage Box Neckpiece*. Nickel, brass, bronze, aluminum, Lucite, found objects. 2 x 5½" (5.1 x 14 cm). Photograph by Will Crocker.

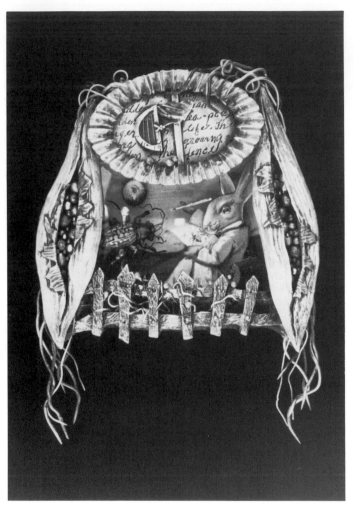

Metal, paper, plastic and found objects are brought together to create this most evocative scene. Robin Kranitsky and Kim Overstreet, *Scrutator*. Brass, copper, silver, plexiglass, postcard fragments and found objects. 2¾ x 2¾ x ¾" (7 x 7 x 1.9 cm).

This work serves as both a pin and a sculpture. Ira Ono, *Brainstorm*. Cast resin, found and recycled materials.

This pin combines image and text to make an aesthetic and socially significant statement. Loes and Robert Pfuelb, *Ann Frank Pin*, 1990. Sterling, 22K gold leaf, postage stamp and graphic elements. Photograph by Ralph Gabiner.

The natural form of the shell inspired the artist to create these bracelets. Pair of pre-Columbian arm ornaments carved from shell. 10th–13th century. The Metropolitan Museum of Art, The Michael C. Rockefeller Memorial Collection, Bequest of Nelson A. Rockefeller, 1979 (1979.206.929-30).

seeds, feathers and nuts could be used to make jewelry. In more contemporary times, the Cubists appreciated the found object and made ample use of it. These innovators incorporated pieces of rope, newspaper or even baskets and toy cars in their painting and sculpture. The Dadaists also enjoyed the found object. They used it to mock the art world by asking where the line between reality and art is drawn. They produced "ready-made" and "ready-made-assisted" works by simply placing a found object on a pedestal or slightly altering a pre-existing form. They forced the viewer to perceive the object as abstract form by taking it out of its customary surroundings and presenting it in a fresh context.

The artist has a well-trained eye that finds extraordinary beauty in what others consider to be ordinary. A scavenger by nature, the artist finds limitless opportunities in mixed-media jewelry making. There is pleasure to be found in the excitement of this hunt. A walk on the beach after a storm may yield a wealth of materials. A stroll down the street may turn up a wonderfully rusted bottle cap that would require pounding and chemical patina solution to duplicate. Garage sales and flea markets are an artist's paradise. Found objects come ready-made with a past life that speaks to us. Though they are often inexpensive, or even free, they are precious to the jeweler.

On the following pages you will find a wealth of ideas for the use of alternative and found materials. The work redefines what is precious in jewelry. It is presented as inspiration and an encouragement to "join the hunt" and bring new materials into the realm of jewelry making. Anything is fair game!

Jewelry Made From Natural Objects

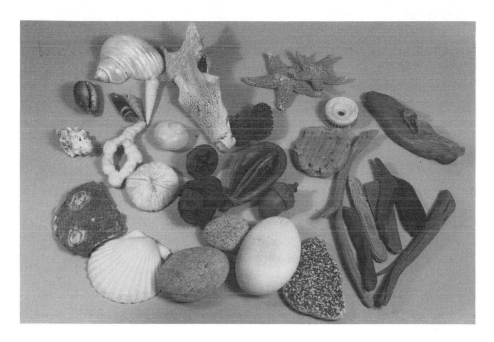

Above: A walk on the beach and through the woods, as well as a bag of potpourri, yielded these natural objects. These shells, weathered wood fragments and seed pods are ready to be glued together to make jewelry.

Right: Pin made by the author from natural materials.

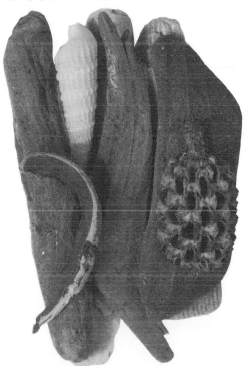

Left: Carved Eskimo ivory necklace, 19th–20th century. The Metropolitan Museum of Art, The Michael C. Rockefeller Memorial Collection, Bequest of Nelson A. Rockefeller, 1979 (1979.206.882).

Right: Sometimes the material you are looking for is no further away than your local butcher shop. This artist boiled and soaked bones in a diluted bleach solution before sawing, carving and filing. To further whiten the bone, she soaked it in hydrogen peroxide. Amy Roper, *Izmir Brooch*. Sterling, brass wire, carved bone. 3½ x 3½" (8.9 x 8.9 cm). Photograph by Ralph Gabriner.

Opposite: The artist arranged hand-painted feathers in a magnificent collar of intricate design and shimmering color. K. Lee Manuel, *Wolf Wing*, 1989. Feathers, acrylic and fabric paint. Photograph by David Reese.

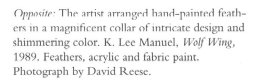

The artist is a collector at heart. She assembles her finds and adds her handmade clay beads to create charming, one-of-a-kind necklaces. Ina Chapler. Tattooed shell, mother of pearl, old glass beads, bone game counter, bone and clay beads and African glass snake beads.

The materials used in this necklace were gathered from the beach and forest floor in the West Indies. Daphne Lingwood, *Necklace and Earring Set*. Fish scales, shells, insect wings, mahogany pods, leather thongs and acrylic paints.

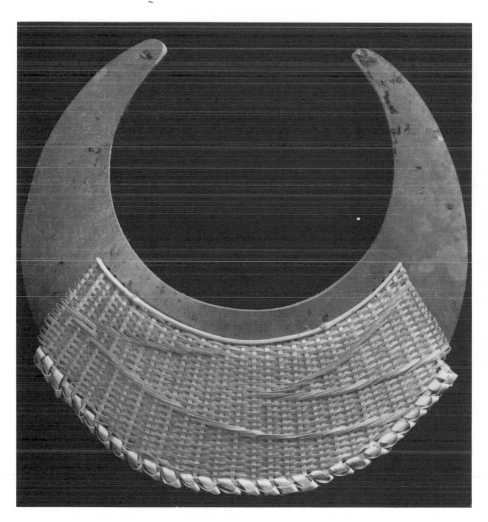

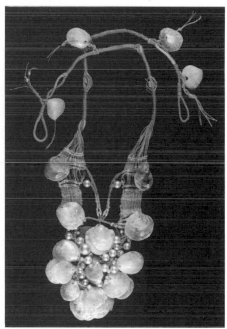

The artist begins with the shell and works spontaneously from there. "The piece practically creates itself." Found materials are often all the inspiration that the artist needs. Kathleen Williams, *Shell Fantasy*. Shells, pearls and waxed linen thread.

These unusual materials were combined by using traditional basketry techniques. John McGuire, *Okokogho*. Hand-prepared black ash splint, calabash, willow and suede. 7½ x 7½" (19.1 x 19.1 cm). Photograph by Dale Duchesne.

Jewelry Made From Mechanical and Electronic Objects

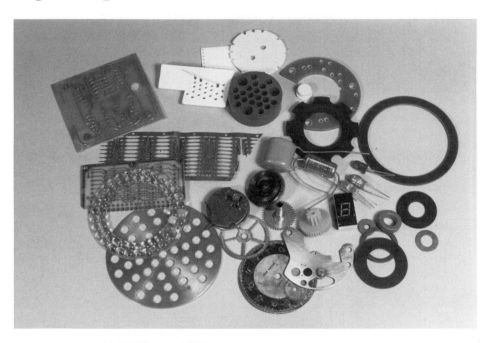

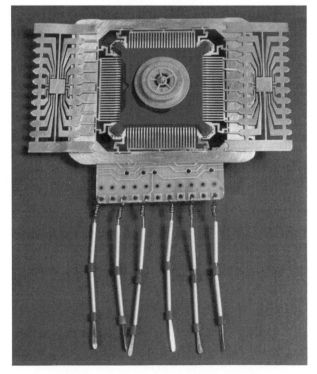

Above: Found mechanical parts often take the form of fascinating shapes that appear to be designed specifically for jewelry.

Left: Pin designed by the author made from electronic parts and a watch gear. Even the wire used in this piece was "extracted" from a small motor. The pieces were glued together and the pin finding was added with 5-minute epoxy glue.

This unorthodox combination of materials is masterfully combined so that they seem quite at home together. Robin Kranitzky and Kim Overstreet, *Crossing Over*. Silver, brass, glass beads, polymer clay, balsa, plexiglass, cotton, copper, lead foil, postcard fragments, watch parts, found objects. $3\frac{1}{2}$ x $2\frac{1}{8}$ x $\frac{3}{4}$" (8.9 x 5.4 x 1.9 cm).

This whimsical story told in found objects and polymer clay is the work of an artist who has a keen eye for integrating diverse objects. Tory Hughes, *The Map Is Not the Territory*, 1991. Fimo, found objects, Mexican glass beads, compass, watch parts and the like.

Jewelry Made From Objects Found Around the Home

Above: Toy parts, game pieces, bottle caps, old glass and shell buttons, coins and other small objects found around the home can be recycled.

Left: Van LeBus, *Cricket Cage Key Chains*. Bullet shell casings, bicycle chain, pop rivets, tennis racket string, copper wire and spring rings.

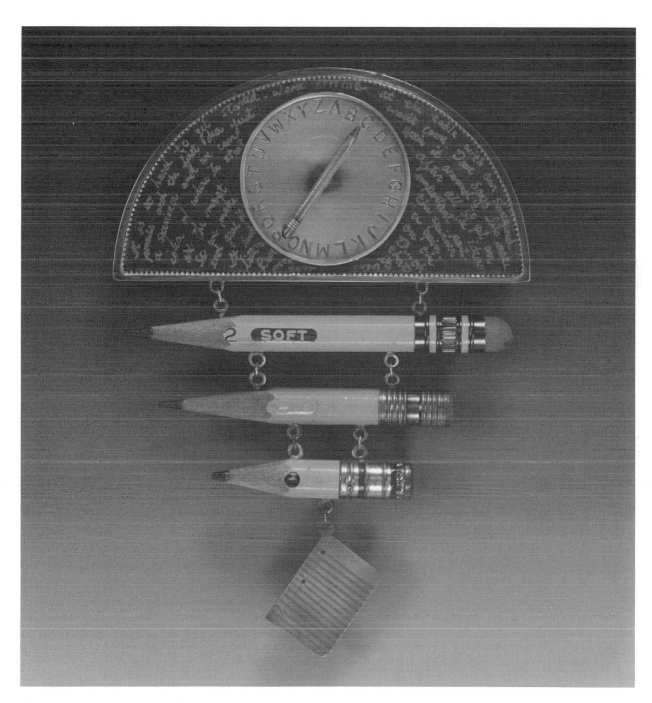

The everyday object can be transformed into an unusual
brooch. Roberta Williamson, *Getting Started*, 1992. Sterling
silver, copper, slate and pencils. 3 x 3½" (7.6 x 8.9 cm).

This pendant combines unusual objects from distant lands and times. Ramona Solberg. Ming pot shard, mother-of-pearl Chinese game piece, porcelain Thai game piece, antique Chinese coin, cast bronze butterfly, sterling silver and blue cotton cord. Photograph by Rod Simmons.

Above: Kiff Slemmons, *Pencil Pie*, 1991. Sterling silver and pencils. 2¾ x ¼" (7 x 0.6 cm). Photograph by Rod Slemmons.

Opposite: The brass elements are sewn onto the zipper in this cut and engraved neckpiece. Kiff Slemmons, *Romance*, 1991. 17 x 2¼ x 1/16" (43.2 x 5.7 x 0.2 cm). Photograph by Rod Slemmons.

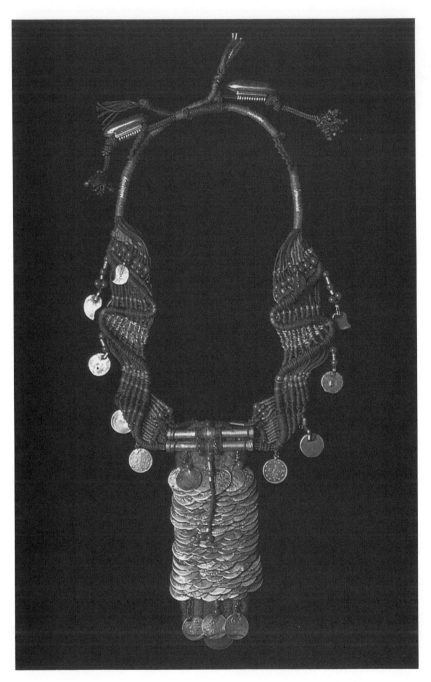

Kathleen Williams, *Turkish Treasure*.
Antique silver coins, silver tubular beads
and colored threads. Photograph by
William Allen.

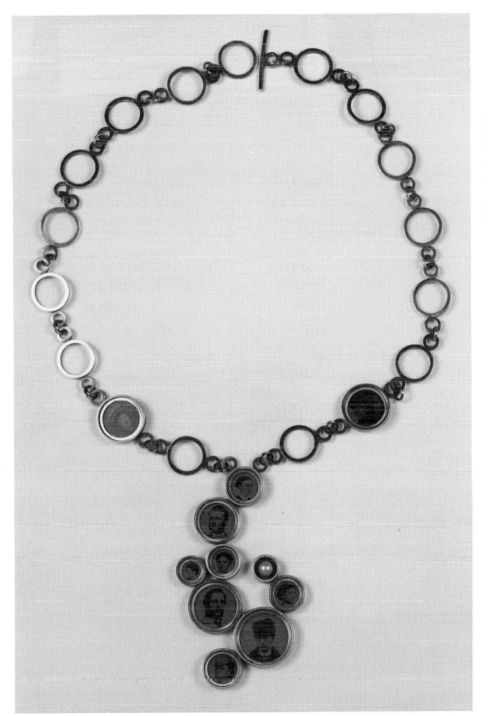

Above: These rubber doll hands were purchased at a crafts store, painted and dressed with lace. The ice cream cone was made from mesh and the cone sprinkles from glass bugle beads. Findings were glued to the hands and the finished piece was coated with clear acrylic for protection. By the author, *Ice Cream and Handkerchief.*

Left: The artist used images from his collection of daguerreotypes and combined them with sterling silver to create this elegant necklace. Julian Wolff. Photograph by Jim Strong.

Glossary

abrasive A cutting substance used with a polishing or rubbing action to produce a variety of surface qualities on metal.

abstraction A design or composition based upon a personal interpretation of an object rather than upon exact visual representation.

amulet A charm worn on the body and believed to possess protective powers.

annealing The process of heating metal to reduce its hardness and brittleness so that it can be more easily formed and shaped.

Baroque Irregular and curving.

bezel A thin metal flange constructed to secure a gemstone.

brittle Easily broken or cracked due to hardness and lack of flexibility.

buff To smooth by polishing with a cloth or powered wheel. Also, a felt, muslin or chamois wheel used for polishing.

burnish To make shiny by rubbing with a polished steel tool.

carat The unit of weight for gemstones. One carat equals $\frac{1}{5}$ gram or $3\frac{1}{16}$ grains troy weight.

chasing A process for surfacing metal by indenting or embossing it with different tools.

compress A process for making a material more compact by pressure.

component One of the parts of a whole unit.

concave Hollow and curved like the inside half of a hollow ball.

conceptualize To form an idea for a design to be translated into materials.

convex Curving outward, as the outside surface of a ball.

core In basketry, the stronger foundation material around which more flexible material is coiled.

crimp To bend into shape or pinch together.

croquis A simple, rough sketch.

cross hatch Two sets of parallel lines that cross each other.

dapping The process of forming metal into domelike shapes.

embellishment Ornamentation.

fabrication Construction by assembling various parts.

facet Any of the polished, flat surfaces cut on a gemstone.

fibula A buckle or clasp for fastening garments (ancient Greece and Rome).

findings The units used for fastening, hinging and joining jewelry.

fine silver Pure silver.

fire scale A gray to purplish oxide that forms on sterling silver.

flame cone The shape of the burning gas from a torch or burner.

forge To form or shape metal with blows from a hammer.

fuse To join by melting.

gauge A standard measure or scale used to designate the thickness of wire and sheet metal.

granular Containing grains or having a grainy texture.

greenware Unfired pottery.

highlight A surface made more light reflective and brighter.

holloware Serving dishes and tableware made from metal.

karat Designation unit for the fineness of gold, $\frac{1}{24}$ part (14 karat gold is 14 parts gold, 10 parts alloy).

lapidary One who cuts, polishes or engraves gemstones.

luster The gloss or sheen of a surface.

malleability A quality in metal that permits bending and shaping without breaking.

mandrel Rods or shapes used as a core around which metal can be formed, shaped and forged.

matte finish A nonreflective, velvety surface on metal.

matting The production of a low reflective surface on metal.

molten Liquefied by heat.

nonobjective design A construction or art form that does not represent any object in nature.

organic Having the characteristics of, or derived from, living organisms.

origami The art of Japanese paper folding.

oxidation A chemical reaction on metal that changes the surface color.

peen The ball or wedge shaped end of a forming hammer.

pickle A chemical bath to clean metal.

pickling To treat with a pickle solution.

pierced design A cutout or drilled opening in a design surface.

planish To flatten, harden or smooth metal by hammering.

porous Full of small openings or pores.

pumice A volcanic rock used in powder form for polishing.

pyrometer A gauge used for measuring the interior temperature of a kiln.

rawhide Untanned or only partially tanned cattle hide.

reciprocating Moving back and forth.

repoussé A process for raising metal from the reverse side to produce a relief design.

resilient Springing back into shape or position after being stretched or compressed.

rouge A ferric oxide powder used in stick form to polish metal.

scarab A black, winged beetle held sacred by the Egyptians, cut from gem material, engraved, and used as a charm.

shank The circular part of a ring that bands the finger.

slip Liquid clay.

stake Wood or metal forms over which metal is hammered to achieve a particular shape.

sterling silver Designation for an alloy of 92.5 percent pure silver.

stylization Depiction in terms of a style rather than in exact visual representation.

surface pitting Small pinpoint depressions that scar metal surfaces.

sweat solder Uniting metal by coating one of the pieces to be joined with a layer of melted solder, then placing the pieces together and reheating so that the solder fuses the joint.

synthesizing Forming or bringing together separate ideas to produce a single solution.

tarnish Discoloration of a metal surface due to oxidation.

taut Tightly stretched.

temper The hardening that occurs in metals when they are formed and forged.

tenacity Toughness, holding together strongly.

texture The treatment of a surface to affect a particular appearance or feel.

tooling Making impressions in leather by compressing it with a tool.

translucent Allowing partial transmission of light.

transparent Allowing nearly complete transmission of light.

tripoli A light colored, fine siliceous earth used for coarse polishing.

undercut An overhanging or concave ledge in the sidewall profile of a mold pattern.

unity The integration of component parts to create completeness.

warp Threads that run lengthwise in a weaving.

wedging Kneading clay to force out trapped air and make it consistent.

weft (or filling) Threads that travel across the warp in a weaving.

wet forming The process of soaking, modeling and then drying vegetable-tanned leather to give it a permanent shape.

wood rasp A coarse file used on wood.

yellow ochre A variety of limonite, consisting of iron oxide and clay. Powdered yellow ochre is mixed with water to form a paste that is used as a heat shield for soldered joints.

ORTON STANDARD PYROMETRIC CONES
TEMPERATURE EQUIVALENTS GUIDE—°F

These temperature equivalent tables are designed to be a guide for the selection of cones. Depending on the firing conditions, the temperature listed may only be a relative guide for the user. The values do provide a good starting point and once the proper cones are determined, excellent, reproducible results can be expected.

Cone Type Heating Rate Cone Number	Large Regular 108°F/hr	Large Regular 270°F/hr	Large Iron Free 108°F/hr	Large Iron Free 270°F/hr	Self-Supporting Regular 108°F/hr	Self-Supporting Regular 270°F/hr	Self-Supporting Iron Free 108°F/hr	Self-Supporting Iron Free 270°F/hr	Small Regular 540°F/hr	Small PCE 270°F/hr	Cone Type Heating Rate Cone Number
022	1074	1092			1087	1094			1157		022
021	1105	1132			1112	1143			1195		021
020	1148	1173			1159	1180			1227		020
019	1240	1265			1243	1267			1314		019
018	1306	1337			1314	1341			1391		018
017	1348	1386			1353	1391			1445		017
016	1407	1443			1411	1445			1517*		016
015	1449	1485			1452	1488			1549*		015
014	1485	1528			1488	1531			1616		014
013	1539	1578			1542	1582			1638		013
012	1571	1587			1575	1591			1652		012
011	1603	1623			1607	1627			1684		011
010	1629*	1641*	1623	1656	1632	1645	1627	1659	1686*		010
09	1679*	1693*	1683	1720	1683	1697	1686	1724	1751*		09
08	1733*	1751*	1733	1773	1737	1755	1735	1774	1801*		08
07	1783*	1803*	1778	1816	1787	1807	1780	1818	1846*		07
06	1816*	1830*	1816	1843	1819	1834	1816	1845	1873*		06
05½	1852	1873	1852	1886	1855	1877	1854	1888	1908		05½
05	1888*	1915*	1890	1929	1891	1918	1899	1931	1944*		05
04	1922*	1940*	1940	1967	1926	1944	1942	1969	2008*		04
03	1987*	2014*	1989	2007	1990	2017	1990	2010	2068*		03
02	2014*	2048*	2016	2050	2017	2052	2021	2052	2098*		02
01	2043*	2079*	2052	2088	2046	2082	2053	2089	2152*		01
1	2077*	2109*	2079	2111	2080	2113	2082	2115	2154*		1
2	2088*	2124*			2091	2127			2154*		2
3	2106*	2134*	2104	2136	2109	2138	2109	2140	2185*		3
4	2134*	2167*			2142	2169			2208*		4
5	2151*	2185*			2165	2199			2230*		5
6	2194*	2232*			2199	2232			2291*		6
7	2219*	2264*			2228	2273			2307*		7
8	2257*	2305*			2273	2314			2372*		8
9	2300*	2336*			2300	2336			2403*		9
10	2345*	2381*			2345	2381			2426*		10
11	2361*	2399*			2361	2399			2437*		11
12	2383*	2419*			2383	2419			2471*	2439*	12
13	2410*	2455*			2428	2458			2460	2460*	13
13½					2466	2493					13½
14	2530*	2491*			2489	2523			2548	2548*	14
14½					2527	2568					14½
15	2595*	2608*			2583	2602			2606	2606*	15
15½					2617	2633					15½
16	2651*	2683*			2655	2687			2716	2716*	16
17	2691*	2705*			2694	2709			2754	2754*	17
18	2732*	2743*			2736	2746			2772	2772*	18
19	2768*	2782			2772	2786			2806	2806*	19
20	2808*	2820*			2811	2824			2847	2847*	20
21	2847*	2856*			2851	2860				2883*	21
23	2887*	2894*			2890	2898				2921*	23
26	2892*	2921*								2950*	26
27	2937*	2961*								2984*	27
28	2937*	2971*								2995*	28
29	2955*	2993*								3018*	29
30	2977*	3009*								3029*	30
31	3022*	3054*								3061*	31
31½	ND	ND								3090*	31½
32	3103*	3123*								3123*	32
32½	3124*	3146*								3135*	32½
33	3150*	3166*								3169*	33
34	3195*	3198*								3205*	34
35	3243*	3243*								3245*	35
36	3268*	3265*								3279*	36
37	ND	ND								3308*	37
38	ND	ND								3362	38
39	ND	ND								3389	39
40	ND	ND								3425	40
41	ND	ND								3578	41
42	ND	ND								3659	42

ND=Not determinded
*Temperature equivalents as determined by the National Bureau of Standards by H.P. Beerman (See Journal of the American Cermaic Society, Volume 39, 1956). Large cones at 2 inch mounting height, Small & PCE cones at 15/16".
1. The temperature equivalents in this table apply only to Orton Standard Pyrometric Cones, heated at the rate indicated in air atmosphere.
2. The rates shown were maintained during the last several hundred degrees of temperature rise.
3. Temperature equivalents are not necessarily those at which cones will deform under firing conditions different from those of calibration determinations.
4. For reproducible results, care should be taken to insure that the cones are set in a plaque with the bending face at the correct angle of 8° from the vertical with the cone tips at a uniform height above the plaque. Self-Supporting Cones are made with the correct mounting height and angle.

ORTON STANDARD PYROMETRIC CONES
TEMPERATURE EQUIVALENTS GUIDE—°C

Cone Type Heating Rate Cone Number	Large Regular 60°C/hr	Large Regular 150°C/hr	Large Iron Free 60°C/hr	Large Iron Free 150°C/hr	Self-Supporting Regular 60°C/hr	Self-Supporting Regular 150°C/hr	Self-Supporting Iron Free 60°C/hr	Self-Supporting Iron Free 150°C/hr	Small Regular 300°C/hr	Small PCE 150°C/hr	Cone Type Heating Rate Cone Number
022	579	589			586	590			625		022
021	596	611			600	617			646		021
020	620	634			626	638			664		020
019	671	685			673	686			712		019
018	708	725			712	727			755		018
017	731	752			734	755			785		017
016	764	784			766	785			825*		016
015	787	807			790	800			843*		015
014	807	831			809	833			880		014
013	837	859			839	861			892		013
012	855	864			857	866			900		012
011	873	884			875	886			918		011
010	887*	894*	884	902	889	896	886	904	919*		010
09	915*	923*	917	938	917	925	919	940	955*		09
08	945*	955*	945	967	947	957	946	968	983*		08
07	973*	984*	970	991	975	986	971	992	1008*		07
06	991*	999*	991	1006	993	1001	991	1007	1023*		06
05½	1011	1023	1011	1030	1013	1025	1012	1031	1042		05½
05	1031*	1046*	1032	1054	1033	1048	1037	1055	1062*		05
04	1050*	1060*	1060	1075	1052	1062	1061	1076	1098*		04
03	1086*	1101*	1087	1097	1088	1103	1088	1099	1131*		03
02	1101*	1120*	1102	1121	1103	1122	1105	1122	1148*		02
01	1117*	1137*	1122	1142	1119	1139	1123	1143	1178*		01
1	1136*	1154*	1137	1155	1138	1150	1139	1157	1179*		1
2	1142*	1162*			1144	1164			1179*		2
3	1152*	1168*	1151	1169	1154	1170	1154	1171	1196*		3
4	1168*	1186*			1172	1187			1209*		4
5	1177*	1196*			1185	1204			1221*		5
6	1201*	1222*			1204	1222			1255*		6
7	1215*	1240*			1220	1245			1264*		7
8	1236*	1263*			1245	1268			1300*		8
9	1260*	1280*			1260	1280			1317*		9
10	1285*	1305*			1285	1305			1330*		10
11	1294*	1315*			1294	1315			1336*		11
12	1306*	1326*			1306	1326			1355*	1337*	12
13	1321*	1346*			1331	1348			1349	1349*	13
13½					1352	1367					13½
14	1388*	1366*			1365	1384			1398	1398*	14
14½					1386	1409					14½
15	1424*	1431*			1417	1428			1430	1430*	15
15½					1436	1445					15½
16	1455*	1473*			1457	1475			1491	1491*	16
17	1477*	1485*			1479	1487			1512	1512*	17
18	1500*	1506*			1502	1508			1522	1522*	18
19	1520*	1528*			1522	1530			1541	1541*	19
20	1542*	1549*			1544	1551			1564	1564*	20
21	1564*	1569*			1566	1571				1584*	21
23	1586*	1590*			1588	1592				1605*	23
26	1589*	1605*								1621*	26
27	1614*	1627*								1640*	27
28	1614*	1633*								1646*	28
29	1624*	1645*								1659*	29
30	1636*	1654*								1665*	30
31	1661*	1679*								1683*	31
31½	ND	ND								1699*	31½
32	1706*	1717*								1717*	32
32½	1710*	1730*								1724*	32½
33	1732*	1741*								1743*	33
34	1757*	1759*								1763*	34
35	1784*	1784*								1785*	35
36	1798*	1796*								1804*	36
37	ND	ND								1820*	37
38	ND	ND								1850	38
39	ND	ND								1865	39
40	ND	ND								1885	40
41	ND	ND								1970	41
42	ND	ND								2015	42

Jeweler's Saw Blade Sizes

SIZE NUMBER	THICKNESS	WIDTH	COMPARATIVE BLADE
8/0	.006″	.013″	(Saws finer than 4/0 not illustrated)
7/0	.007	.014	
6/0	.007	.014	
5/0	.008	.015	
4/0	.008	.017	
3/0	.010	.019	
2/0	.010	.020	
0	.011	.023	
1	.012	.025	
2	.014	.027	
3	.014	.029	
4	.015	.031	
5	.016	.034	
6	.019	.041	
8	.020	.048	
10	.020	.058	
12	.023	.064	
14	.024	.068	

Scale of File Cuts

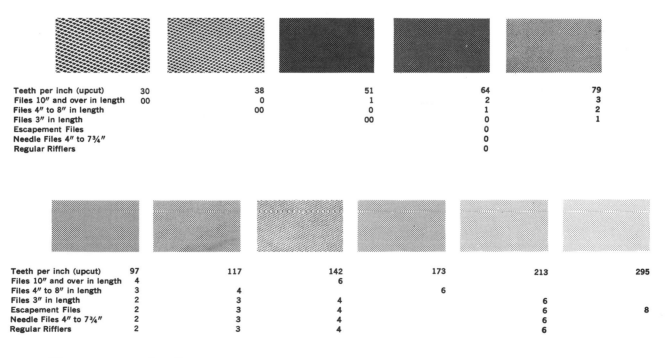

Teeth per inch (upcut)	30	38	51	64	79
Files 10″ and over in length	00	0	1	2	3
Files 4″ to 8″ in length		00	0	1	2
Files 3″ in length			00	0	1
Escapement Files				0	
Needle Files 4″ to 7¾″				0	
Regular Rifflers				0	

Teeth per inch (upcut)	97	117	142	173	213	295
Files 10″ and over in length	4		6			
Files 4″ to 8″ in length	3	4		6		
Files 3″ in length	2	3	4		6	
Escapement Files	2	3	4		6	8
Needle Files 4″ to 7¾″	2	3	4		6	
Regular Rifflers	2	3	4		6	

Charts courtesy of William Dixon Company

Findings

a)

b)

c)

d)

e)

f)

g)

h)

Art copyrighted by Ornamental Resources, Inc. Reprinted by permission

Findings

a. Pierced and unpierced earring findings
b. Pin backs
c. Chain
d. Head pins (for hanging beads)
e. Clasps
f. End caps and cone (for ending multiple strands or cords)
g. Jump rings (for linking one element to another)
h. Barrette finding

Sources of Supply

General Supplies

New York Central Art Supply
62 Third Avenue
New York, NY 10003

Pyramid Art Supply
P.O. Box 877
Urbana, IL 61801-0877

Jewelry-Making Tools and Supplies

Allcraft Tool and Supply Company, Inc.
666 Pacific Street
Brooklyn, NY 11217
or
45 West 46th Street, 3rd Floor
New York, NY 10036

Anchor Tool and Supply Company, Inc.
Box 265
Chatham, NJ 07928-0265

Gesswein
P.O. Box 3998
255 Hancock Avenue
Bridgeport, CT 06605

Grobet/Hammel/Dixon
750 Washington Avenue
Carlstadt, NJ 07072

Otto Frei and Jules Borel
P.O. Box 796
126 Second Street
Oakland, California 94604
or
760 Market Street
San Francisco, California 94102

Rio Grande
6901 Washington N
Albuquerque, NM 87109

Clay Supplies

American Art Clay Company, Inc. (AMACO)
4717 West 16th Street
Indianapolis, IN 46222
(Large selection of clay tools and supplies, clay: ceramic and polymer)

Ceramic Supply of New York and New Jersey, Inc.
534 La Guardia Place
New York, NY 10012
or

#7 Route 46 West
Lodi, NJ 07644
(Ceramic Supplies)

Clay Factory of Escondido
P.O. Box 460598
Escondido, CA 92046-0598
(Fimo and Cernit polymer clay)

Minnesota Clay
8001 Grand Avenue South
Bloomington, MN 55420
(Colored clays and books)

Polyform Products Company
P.O. Box 2119
9420 Byron Street
Schiller Park, IL 60176
(Manufacturers of Sculpey polymer clay)

Glass and Glass-Crafting Supplies

Stained Glass Workshop
536 Jericho Turnpike
Syosset, NY 11791

Studio J
1239 Main Avenue
Clifton, NJ 07011

Sunshine Glassworks Ltd.
240 French Road
Buffalo, NY 14227

Thompson Enamel
P.O. Box 310
Newport, KY 41072
(Enameling supplies, lead-free enamels and overglaze painting colors)

Beads

Beadworks
139 Washington Street
South Norwalk, CT 06854
(Beads from around the world)

BeadZip
2316 Sarah Lane
Falls Church, VA 22043
(Beads, findings, books. Catalogue $5, returnable with first order)

Optional Extras, Inc.
150A Church Street
Burlington, VT 05401

Ornamental Resources, Inc.
P. O. Box 3010-JTM
Idaho Springs, CO 80452
(Large selection. Their 350-page catalog in three-ring binder is $25, which includes supplement subscription and discount)

Fiber Supplies

Blueprints—Printables
Department C
1504 #7 Industrial Way
Belmont, CA 94002
(Blank silk earrings. Accessories section of catalogue, $1)

Cerulean Blue, Ltd.
P.O. Box 21168
Seattle, WA 98111-3168 [Lumiere and Neopaque fabric paints]
(Fabric paints, dyes, white and black silk and supplies)

Clotilde Inc.
1909 S.W. First Avenue
Fort Lauderdale, FL 33315-2100

Home-Sew
P.O. Box 4099
Bethlehem, PA 18018-0099
(A good source for lace)

Findings, Metal, Stones and Tools

Indian Jewelers Supply Co.
P.O. Box 1774
Gallup, NM 87305-1774
(Also a good source for tools)

Myron Toback, Inc.
25 West 47th Street
New York, NY 10036

River Gems and Findings
6901 Washington St. NE
Albuquerque, NM 87109-4490

Leather Supplies

Tandy Leather Company
P.O. Box 791
Fort Worth, TX 76101
or see your local Yellow Pages for the store
nearest you

Other

Crooked-River Crafts, Inc.
P.O. Box 129
413 Main Street
La Farge, WI 54369
(Watch and computer parts, seed and bugle beads, beading supplies and findings)

Jackson-Hirsh, Inc.
700 Anthony Trail
Northbrook, IL 60062-2542
(Laminating film, laminators)

Lab Safety Supply
P.O. Box 1368
Janesville, WI 53547-1368
(Safety supplies including goggles, respirators and ventilation hoods)

Reactive Metals Studio, Inc.
P.O. Box 890
Clarkdale, AZ 86324
(Miniature nuts and bolts, patterned metal)

TSI, Inc.
101 Nickerson Street
Seattle, WA 98109
(Beads, findings, metal, Fimo and books)

Bibliography

General

Fitch, Janet, *The Art and Craft of Jewelry*. New York: Grove Press, 1992.

McCann, Michael, *Artist Beware*. New York: Lyons & Burford Publishers, 1992.

Meilach, Dona, *Ethnic Jewelry*. New York: Crown Publishers, Inc., 1981.

Rossol, Monona, *The Artist's Complete Health and Safety Guide*. New York: Allworth Press, 1990.

Sprintzen, Alice, *Crafts: Contemporary Design and Technique*. Worcester, MA: Davis Publications, Inc., 1987.

Clay

Bodger, Lorraine, *Woman's Day Dough Crafts*. New York: Sedgewood Press, 1983.

Brody, Harvey, *The Book of Low-Fire Ceramics*. New York: Holt, Rinehart and Winston, 1979.

Meilach, Dona, *Creating Art with Bread Dough*. New York: Crown Publishers, Inc., 1976.

Nan Roche, *The New Clay*. Rockville, MD: Flower Valley Press, 1991.

Nelson, Glenn C., *Ceramics: a Potter's Handbook*. New York: Holt, Rinehart and Winston, Inc., 1971.

Fiber

Dodson, Jackie, *How to Make Soft Jewelry*. Radnor, PA: Chilton Book Company, 1991.

Johnston, Meda Parker, and Glen Kaufman, *Design on Fabrics*. New York: Van Nostrand Reinhold Company, 1967.

Koehler, Nancy Howell, *Soft Jewelry: Design, Techniques, & Materials*. Englewood Cliffs, NJ: Prentice-Hall, Inc., 1977.

Meilach, Dona, *Soft Sculpture and Other Soft Art Forms*. New York: Crown Publishers, Inc., 1974.

Proctor, Richard M., and Jennifer F. Lew, *Surface Design for Fabric*. Seattle and London: University of Washington Press, 1984.

Sommer, Elyse and Mike, *Wearable Crafts*. New York: Crown Publishers, Inc., 1976.

Glass

DeLange, Deon, *Techniques of Beading Earrings*. Ogden, Utah: Eagle's View Publishing Company, 1983.

Kinny, Kay, *Glass Craft*. Radnor, PA: Chilton Book Company, 1962.

Lundstrom, Boyce, and Daniel Schwoerer, *Glass Fusing—Book One*. Portland, OR: Vitreous Publications, Inc., 1983.

Moss, Kathlyn, and Alice Scherer, *The New Beadwork*. New York: Harry N. Abrams, Inc., 1992.

Rothenberg, Polly, *The Complete Book of Creative Glass Art*. London: George Allen & Unwin Ltd., 1974.

White, Mary, *How To Do Beadwork*. New York: Dover Publications, 1972.

Leather

Garnes, Jane, *The Complete Handbook of Leathercrafting*. Blue Ridge Summit, PA: Tab Books, Inc., 1981.

Hayden, Nicky, editor, *Leather*. New York: Charles Scribner's Sons, 1979.

Hills, Pat, *The Leathercraft Book*. New York: Random House, 1973.

Lingwood, Rex, *Leather in Three Dimensions*. Toronto, Canada: Van Nostrand Reinhold, Ltd., 1980.

Newman, Thelma R., *Leather as Art and Craft; Traditional Methods and Modern Designs*. New York: Crown Publishers, Inc., 1973.

Metal

Evans, Chuck, *Jewelry: Contemporary Design and Technique*. Worcester, MA: Davis Publications, Inc., 1983.

Fisch, Arline, *Textile Techniques in Metal for Jewelers, Sculptors, and Textile Artists*. New York: Van Nostrand Reinhold, 1975.

McCreight, Tim, *The Complete Metalsmith*, revised edition. Worcester, MA: Davis Publications, 1991.

Schiffer, Nancy, *Jewelry by Southwest American Indians: Evolving Designs*. West Chester, PA: Schiffer Publishing, Ltd., 1990.

Sprintzen, Alice, *Jewelry: Basic Technique and Design*. Radnor, PA: Chilton Book Company, 1980.

Untracht, Oppi, *Jewelry Concepts and Technology*. Garden City, NY: Doubleday and Company, Inc., 1982.

Paper

Jackson, Paul, *The Encyclopedia of Origami and Papercraft Techniques*. Philadelphia, PA: Running Press, 1991.

Jackson, Paul, and Vivien Frank, *Origami and Papercraft: A Step-by-Step Guide*. New York: Crescent Books, 1988.

Kasahara, Kunihiko, *Creative Origami*. Tokyo: Japan Publications, Inc., 1976.

Kasahara, Kunihiko, *Origami Omnibus*. Tokyo and New York: Japan Publications, Inc., 1988.

Kenneway, Eric, *Complete Origami*. New York: St. Martin's Press, 1987.

Newman, Thelma, Jay Hartley Newman, and Lee Scott Newman, *Paper as Art and Craft: The Complete Book of the History and Processes of the Paper Arts*. New York: Crown Publishers, Inc., 1973.

Zeier, Franz, *Paper Constructions: Two- and Three-Dimensional Forms for Artists, Architects, and Designers*. New York: Charles Scribner's Sons, 1974.

Periodicals

American Craft, American Craft Council, Membership Department, P.O. Box 3000, Denville, NJ 07834-9805. Bimonthly.

Art Hazards News, Center for Safety in the Arts, 5 Beekman Street, Suite 1030, New York 10038. Five issues per year.

Ceramics Monthly, P.O. Box 12448, Columbus, OH 43212-9988. Monthly.

The Crafts Report, The Crafts Report Publishing Company, Inc., P.O. Box 1992, Wilmington, DE 19899-9962. Monthly.

Fiberarts, 50 College Street, Asheville, NC 28801. Five issues per year.

Glass Art, P.O. Box 1507, Broomfield, CO 80038-1507. Bimonthly.

Metalsmith, Journal of the Society of North American Goldsmiths (SNAG), 5009 Londonderry Drive, Tampa, FL 33647. Quarterly.

Professional Stained Glass, 28 South State Street, Newtown, PA 18940. Bimonthly.

Ornament, Post Office Box 2349, San Marcos, CA 92079-9806. Quarterly.

Sites of Crafts Workshops

Arrowmont School of Arts and Crafts, Box 567, Gatlinburg, TN 37738.

Brookfield/SoNo Craft Center, P.O. Box 122, Brookfield, CT 06804.

Dunconor Jewelry Workshops, P.O. Box 149, Taos, NM 87571.

Haystack Mountain School of Crafts, Box 518, Deer Isle, ME 04627.

Horizons New England Craft Program, 374-A Old Montague Road, Amherst, MA 01002.

Mother Earth Father Sky Native Arts and Cultures Workshops, Idyllwild Arts Foundation, P.O. Box 38, Idyllwild, CA 92349.

Penland School, Penland, NC 28765.

Peters Valley Craft Center, 19 Kuhn Road, Layton, NJ 07851.

Southwest Craft Center, 300 Augusta, San Antonio, TX 78205.

Index